10/96

Fallen Angels

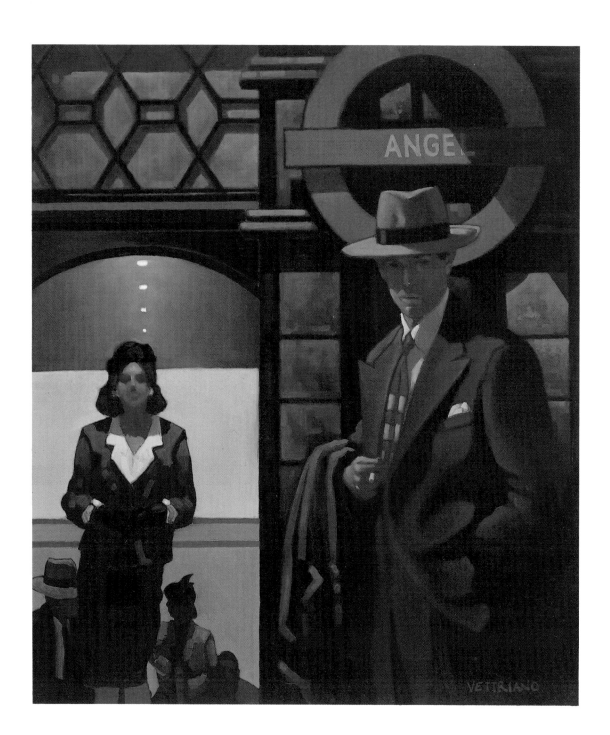

PAINTINGS BY
JACK VETTRIANO

EDITED BY
W GORDON SMITH

 FALLEN ANGELS

Words by

Stewart Conn

Ian Hamilton Finlay

Alasdair Gray

Sue Glover

Joy Hendry

Robin Jenkins

A L Kennedy

Joan Lingard

Norman MacCaig

Bernard MacLaverty

Alan Sharp

Iain Crichton Smith

PAVILION

First published in Great Britain in 1994 by
PAVILION BOOKS LIMITED
26 Upper Ground
London SEl 9PD

Designed by Bernard Higton

A CIP catalogue record for this book is available from the
British Library

ISBN 1-85793-384-2
Pbk 1-85793 5683

Printed and bound in Spain by Cayfosa

10 9 8 7 6 5 4 3 2 1

This book may be ordered by post direct from the publisher.
Please contact the Marketing Department. But try your bookshop first.

CONTENTS

INTRODUCTION

W GORDON SMITH

Where did it all begin? On the boat from Italy at the turn of the century which brought the Vettrianos out of the sun to the shores of a grey but hospitable land? In the family home in Fife, where a thoughtful grandfather kept a sketching laddie stocked with paper and pencils filched from the local betting shop? Was it the lass who, amazed by the young man's drawing skills, gave him his first set of watercolours? How did the Hollywood dream machine grind into a mind avid for escapist romance? Did some genetic inheritance – as Alasdair Gray has suggested – even hundreds of feet underground in the Fife coalfield, throw up visions of the human comedy played out in gilded light under high Renaissance skies?

Some – or maybe all – of those influences drove the former mineworker Jack Vettriano to the point where, without any formal art instruction, he decided to become a painter. In 1988 he submitted canvases to the Royal Scottish Academy's annual exhibition. They were hung and sold. A 1991 show at the Solstice Gallery during the Edinburgh Festival was so successful that his first major solo exhibition was planned for the autumn of 1992. That sell-out was preceded by three paintings being hung in London at the Summer Exhibition of the Royal Academy. Since then he has had several shows in London and Newcastle.

His style has been compared to Hopper and Sickert, the moral ambiguities of his sensual dalliance likened to the photography of Brassaï, his scudded beaches inspired by Boudin. Yet he is, incontrovertibly, his own man. Life indoors is a peep-show played out by characters caught up in some shadowy limbo. Or out in an infinity of open space, small dramas tease and unravel. Passion, desire, threat, seduction and betrayal stalk boundaries between virtue and vice. There is an adoration of women and an indulgence of men, an acknowledgement of weakness and corruption, but neither censure nor approval. The ringmaster musters his cast, cracks the whip, and ritual dances begin. Plot and dialogue and subtext is in the mind of the beholder.

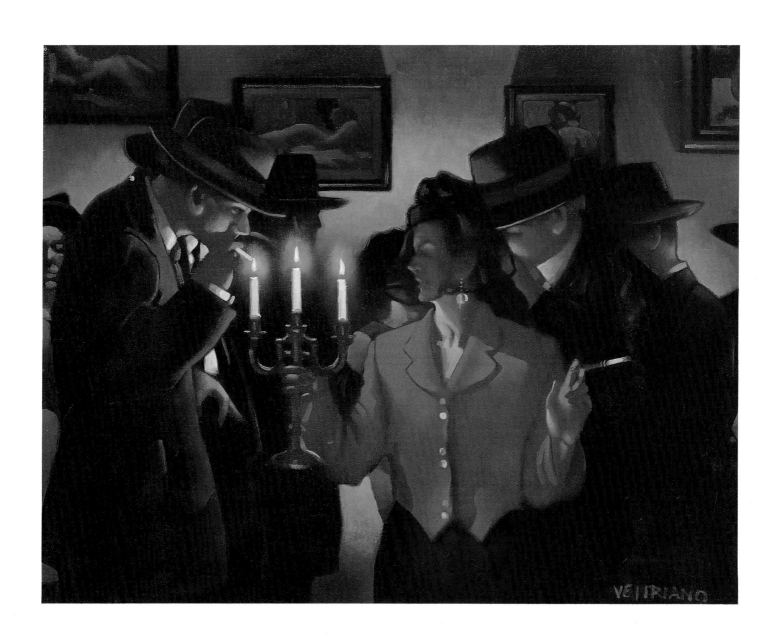

When it was suggested to me that a book of Vettriano's paintings might be accompanied by Scottish writing I immediately recommended an anthology of new short stories, contemporary poetry, extracts from plays and novels, and resonant fragments from the past. Writers were asked to respond to the paintings, neither explain nor describe them, but intrude and interpret, using the visual images as a trampoline for their own imagination, or try to find in them reverberations of work already accomplished. They saw catalogues of paintings going back to 1990 and photographs of canvases still wet on the easel.

Exiled on a tiny New Zealand island, novelist and screen writer Alan Sharp found a chapter of 'a book in progress' which chimed with uncanny coincidence. I remembered an early Ian Hamilton Finlay romance tugging at my male heartstrings. Passages from Joan Lingard's latest novel, the poetry of Norman MacCaig, lyrics from a new Sue Glover drama, extracts from two of my own plays, and bright threads from the skein of Scottish literature echoed back by happenstance. Even William Laughton Lorimer's lifework, the translation of the New Testament into Scots, offered up a jewel of commentary.

But it is the new writing, stimulated by the implicit narrative of Vettriano's work, which complements the paintings with such vivid and varied intensity. Alasdair Gray – painter as well as renowned novelist – was roused to polemic. Russell Hunter, veteran Scottish actor, found himself among the street bookies of his Gorbals childhood. Singer Benny Gallagher commemorates Scottish-Italian teenage joys with an affectionate lyric. The octogenarian novelist Robin Jenkins produced one love poem, the sexagenarian poet Iain Crichton Smith another. A younger poet, Stewart Conn, candidly confronts the artist's arousal of carnal desires. Joy Hendry and Sue Glover decided to defend their gender with feral claws. In the throes of a new novel and insistent requests for her work A L Kennedy demanded that one image above all others, a sinister Vettriano set-piece, should be allowed to provoke her own dark musings. Carl MacDougall turned a brief visual encounter into an extended surrealist fantasy. Jack Gerson, Bernard MacLaverty and Alan Taylor found stimulus in Vettriano's regurgitation of laidback American movie culture.

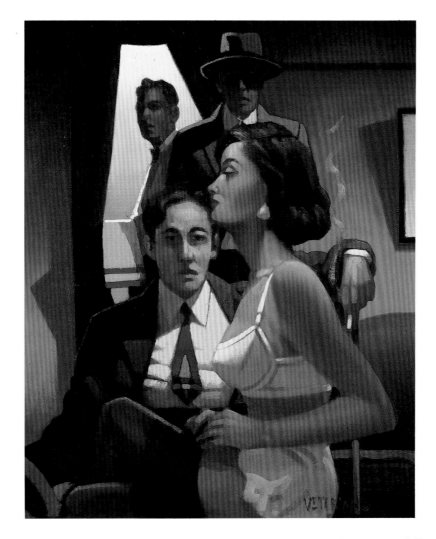

The artist – and those of us who have seen his paintings sell so successfully off gallery walls – have wondered how he manages to speak so directly, in his own idiosyncratic voice, to so many people across so many barriers of established taste and cultivated judgment. There is no simple answer. But his fellow Scottish artists, writers and poets of several generations, have welcomed him with their own homage, and he is suitably flattered.

THE CONTENTS OF MY POCKET

CARL MacDOUGALL

I carry time in my pocket, mingled with fragments of my former selves.

Small sections are with me for a while. Some are discarded or depart from necessity, but a few stay to remind me of other times, when I was different from whoever I am today.

The layers become dust which mixes with the other dusts in my pocket, forming a stoor which is indistinguishable from what I used to be. Only a scientist could separate the particles, could tell which grain came from which self, though I like to think I know the differences.

Parts are shaved from objects in my pockets to join with particles from the other objects, creating a history, falling off like memories. Time sheds particles in the shape of images, furniture, machinery, newspapers, buildings and so on. You neither need to peel the layers nor analyse the dust; it's there, in the object; and these objects are scattered all over the place, in libraries and museums, in old houses, attics and cellars, filing cabinets, envelopes or cardboard boxes; bits of paper.

Think of me as a building, my pockets as rooms and you'll know what I mean. The air is fresh and alive with memory. The objects in my pockets are the furniture. Dust, on the other hand, will always be dust.

I empty my pockets every night. Just before bed, I clear my rooms by emptying the contents of my pockets onto the small walnut table by the side of my bed. It holds a lamp, an alarm clock, perhaps a book and the contents of my pockets.

1: A white linen handkerchief, unused. This item comes from my right hand trouser pocket. It has been folded, ironed and in my pocket for three days. There are traces of dust around the edges.

2: £8.60. From my left hand trouser pocket, comprising one Bank of England

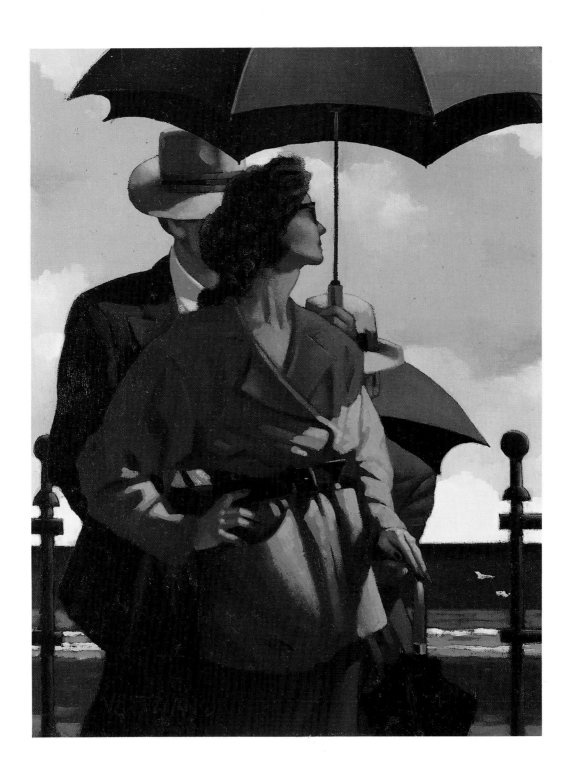

£5 note, two Royal Bank of Scotland £1 notes, a £1 coin, one 50p piece and a 10p piece.

3: 98p. From my hip trouser pocket, comprising four 20p pieces, three 5p pieces, one 2p piece and a 1p piece. Any coin below 10p and 20p coins I try not to spend when I am given them in change. I pocket them separately and take them to the bank.

4: A bunch of keys, three for the front door and four others whose purpose I have forgotten, on a ring decorated with a small brass anchor. I do not throw the useless keys away in case I may one day remember their usefulness. There are too many keys on the ring. It has made a hole in my jacket pocket, which the keys will soon fall through, then bruise the lining.

5: A gold-nibbed Parker fountain pen, light weight and tortoiseshell, a present from a woman who gave me the pen when we parted. I know you're broke, she said. God knows you've told me often enough. No matter how broke you are, I'll never give you money. I'll buy you food and buy you clothes. You can have nice things, but no money.

I have a wallet for my credit cards, and a wallet for my cheque book. And that's the inventory of things that lie on the walnut table, except for the watch, gold and steel, black and white face with a diamond chip inset, very tasteful, by Rolex of Switzerland. Another parting gift from someone who would not give me money.

When I've emptied my pockets I undress and hang up my clothes. My room is by the sewer. At night I wait for the frogs to jump. No one believes me. They come out at night. I can see them jump below the street lights. They are small and shiny. They jump like bits of light, like little ideas trying to soar, forced down to earth. I cannot see what I love about frogs, their markings and their legs. They come up from the drains, out of the earth to jump.

My room is small with a James Dean poster on the wall. My landlady says she worries about me. You should look after yourself, she says, or get yourself looked after properly. Do you eat? I don't think you eat. I never see you cooking. I think you starve yourself. I think you need looking after.

If the frogs don't come, I look across the street, to where there's light in the bedroom window. I call her Susan. The husband spends time away from home.

He leaves on Monday morning, drives away in his big black car and does not return until Friday night or Saturday morning.

At night I search for a gap in the curtains or imagine her moving round the room in a silken dressing gown that sweeps behind as she walks. I imagine her lying in bed, a heap of pillows behind her head, reading and smoking, or watching a late night film on television.

I have seen her walking in the late afternoon; walking along the promenade, with the wind coming in from the sea, blowing her shortish hair. She was wearing sunglasses. I saw her from behind, knew it was her and was about to move along beside her, about to say something, I don't know what, something like, I don't think you know me. We haven't met, not formally, but I thought I'd introduce myself. Did you know we are neighbours? Have you ever seen the frogs?

As I was about to speak, she turned and spoke to someone, a woman in a red spotted dress, a woman who looked the same age as herself. They did not appear to be friends; workmates, associates, two women with a shared interest, rather than friends. They chatted for a while, then walked to a café where they ordered tea and smoked and talked until after five o'clock.

I'll go down to the shore to see her again. I'll talk about the frogs, weather, sun and cloud, the blustery days that change from one thing to another, lovely weather for the time of year. If she is with someone I will ignore them, even her husband. I'll ignore everyone except her.

I'll bring her here and tell her what I think when I cannot see the frogs, when her light is on at night and I imagine her reading in bed, bored and alone.

I could write a letter, but I don't know her name. I could put the letter through the door, telling her what I've already said and saying I almost spoke on the promenade and if she's going to be there again, this afternoon, walking by the front, I'll talk to her then. She'll know me. She'll know my straw hat with the red and blue band which I'll raise when I see her.

So this is the same and it's here again. My pockets are empty. The pen is ready, primed and loaded, scattering dust, recording the life and the parts that beat.

POWER DIVE

NORMAN MacCAIG

He spent a fortune on architects and builders.
He signed tickertapes of cheques for furniture,
carpets, paintings, filmstar beds. He surrounded the
house with plantations and parterres, hahas and gazebos.
And in the right place, the properest place
at last he saw completed a swimmingpool
that glittered like ancient Rome.

It was just before he hit the water
in his first dive that he glimpsed
the triangular fin cutting the surface.

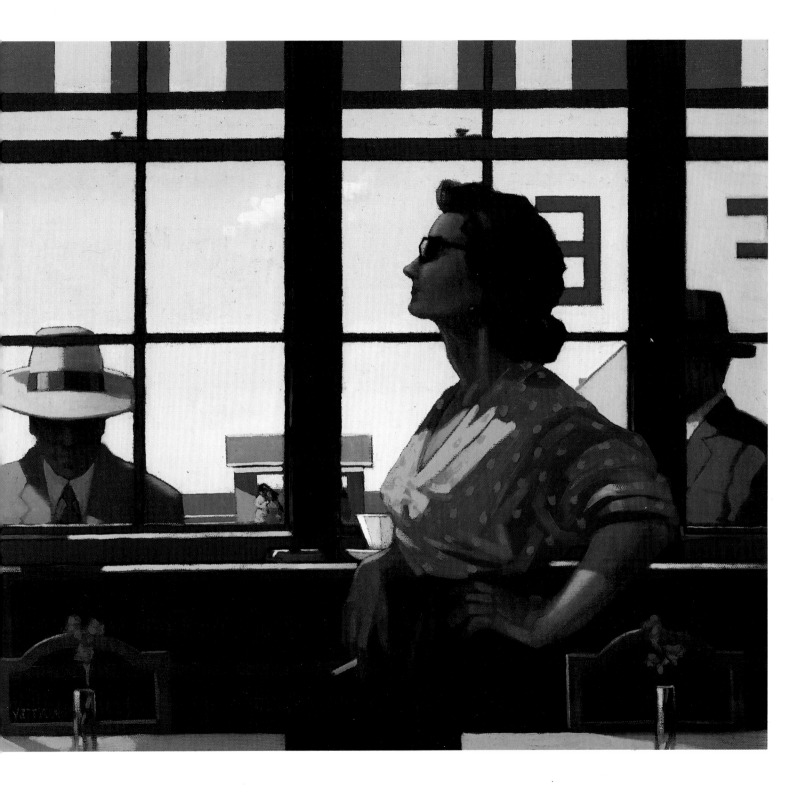

THE SPORT OF KINGS

RUSSELL HUNTER

Nowadays you surround yourself with home comforts, study form, a dram at your elbow, phone handy, smoked salmon sandwiches on call. The telly parades the gee-gees, updates the odds, interviews jockeys and trainers, runs through the card somewhere or other – Uttoxeter, Haydock, Redcar. Places which, if they had no racecourse, might have no name. Places which used to turn guys who left school at fourteen into ambient gazetteers with an astonishing grasp of British geography. This matched their Einsteinian faculty with figures. They might be able to spell no other name but their own, yet would need no electronic calculator to work out every last penny the bookmaker owed them after a once-in-a-lifetime win with a labyrinthine bet.

Of course you might be sitting in one of the executive boxes at Ibrox or Old Trafford. Waiter service, telly twinkling in the corner – while you watch the game with half an eye – and dial the hotline to the man who holds the title deeds of your house as collateral against your gambling extravagances. Or perhaps you're lolling back in any of the thousands of Sanderson-flocked betting shops where the sense of being at the races is fortified by crackly on-course commentary which sounds as if the horses are trying to leap the craters of the moon.

Where I came from in the years before the Second World War – from the Gorbals of Glasgow – the horses did run on the moon. Or at least in some outlandish place that was also made of green cheese. So distant from my own grassless ken, so divorced from tenemental reality, where the only horses you ever saw pulled milk or bags of coal or gave big polis the clout of Ivan the Terrible. And the only way you could place a bet on these mythical beasts that ran on green stuff called turf at toff places called Ascot and Goodwood was to break the law. Of course, in itself, that was nothing new.

Genetically, the street bookie was endowed with extra pairs of eyes. He pitched himself so strategically at a closemouth – those cavernous entrances to

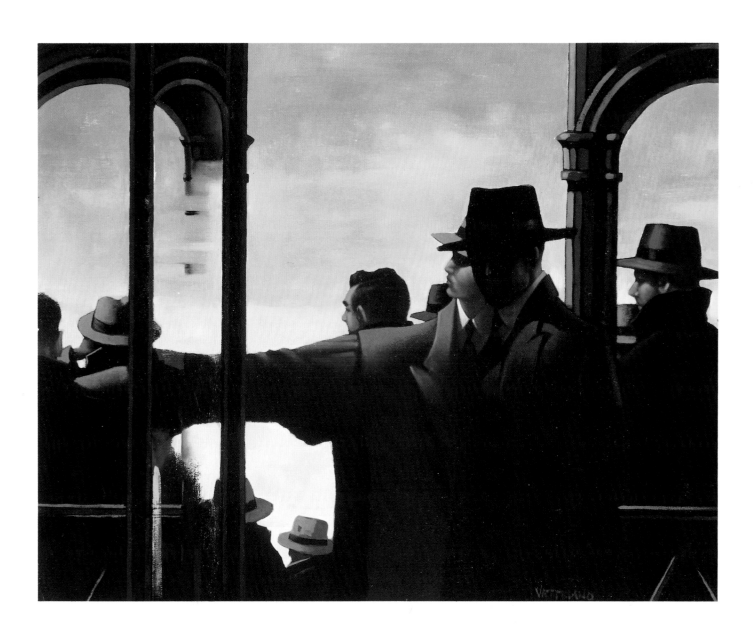

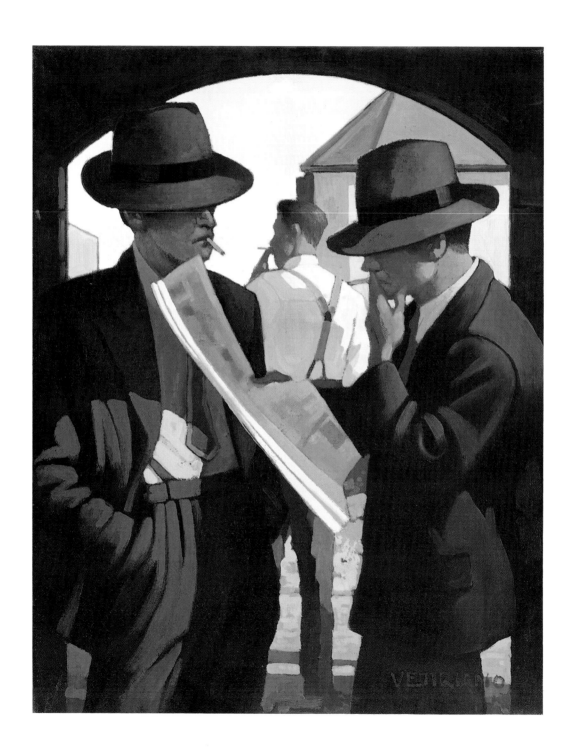

tenements – that he was able to cover four street corners at once. He used the eyes in the back of his head to protect his rear, the approach most favoured by sneaky law officers, who crawled through palings, dreeped from washhouse roofs and clambered over middens to accost their quarry.

The street bookie was a local hero. Like the women of the streets he was arrested on a regular basis and made to pay fines which were generally understood to be a hypocritical society's moral way of living off immoral earnings. You could spot him at fifty yards – nattily dressed, hair parted in the middle and gleaming with brilliantine. His minions – the bookies' runners – were the rag-tag-and-bobtail of the business. They were his early warning system, his debt collectors, his intelligence service. They shuffled the streets with their "wee messages", fetching and carrying their scruffy slips of paper, winging in bets from factory and workshop, pubs and billiards saloons, delivering contracts between the bookie and pseudonymous clients like BIGBEAR and Tanzielug, Autolycus and YO-HO-HO.

To understand the bets you have to understand pre-decimal old money – L s d, twenty shillings to the pound, twelve pennies to the shilling. As you will see the optimism of dreams has not changed. The "widow's mite" was a threepenny double – two horses selected; if both won at three to one she would collect four shillings. The "big man's" bet – actually eleven bets at 3d a time – staked 2s 9p but involved four horses and the prospect of six doubles, four trebles and one roll-up; if three of his horses won he might collect more than £1 which could have been as much as a week's wages. Then there was the "one in a million". Six horses selected in a single bet called a threepenny roll-up. All six horses had to win. At average odds of only two to one the payout would have been a thundering £9 2s 3d, and with whisky at 62p a bottle (in today's money) the working man could honestly believe he participated in the sport of kings.

The street bookie was many things to most men. He was in some senses their bank, their bingo and their pawnshop. Contrary to general belief bookies were very honest. They had to be – they lived at the heart of the community and were an essential part of its texture and fabric. They were relied upon and trusted in times of trouble. I miss them.

THE SINGING BUTLER

JOY HENDRY

Da da de da da –
ti tum – ti tum
Da da de da da –

Lovely day, Sir,
well – when I get the angle of the brolly right –
Couldn't be better.

There we are: da da de da da –
Aw, now, just look at the two of you
perfect, if I may say so,
moulded to each other,
line for line – like you was made…

Let's keep God out of it!

Now, just –
if I might be so bold, Sir,
yes, just slip your hand a little up
and across the back –
support her with the fingertips
as well as the heel of your hand –
like you'd hold a baby's head…
Now glide – e-a-s-y.
That's it!

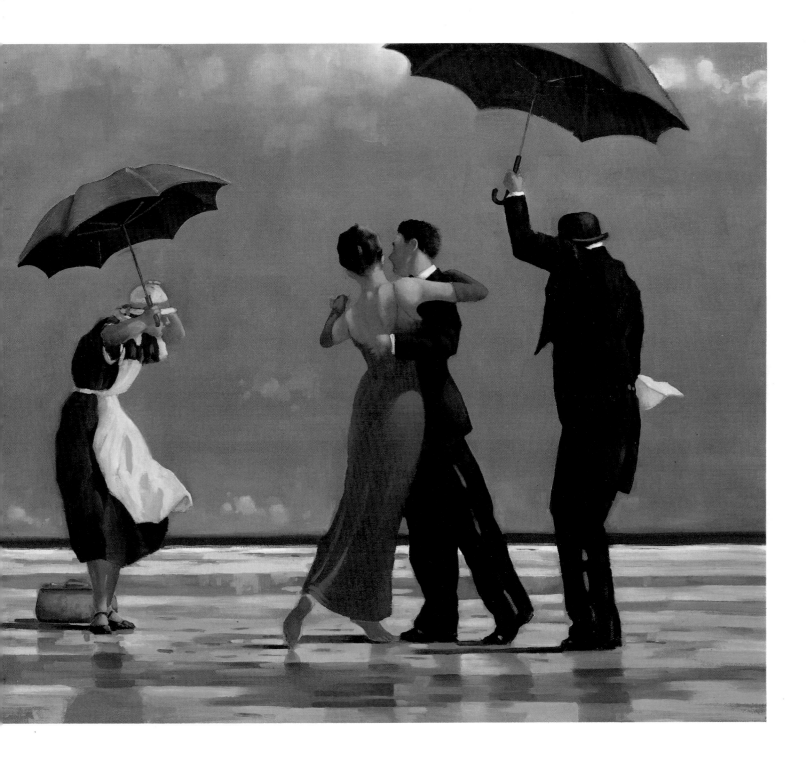

THE SINGING BUTLER

Well, as near as you'll get, I'll warrant.
You can dance to my da-de-das
as long as you like,
in rain, wind, hail, fire or thunder
– you name it –
but you'll *never really be dancing.*

But my Florrie over there, she'll be dry.
You *wouldn't notice, but* she's *got her* own *umbrella.*
You wouldn't notice, but she's looking over yonder
to the horizon – she sees far, does my Florrie.

She'll be lost in all them colours,
the dark blue line where sea meets sky,
the white spray of the breakers,
the layers of sand shimmering golden under your dancing feet,
transported to a distant magic planet, she'll be.
She sees more than I dare think – does my Florrie,
though you wouldn't realise, to look at her…

Da-da-de-da-da. Ti-tum
Ti-tum.
Lovely turn, Sir.
Elegant. You've got style!

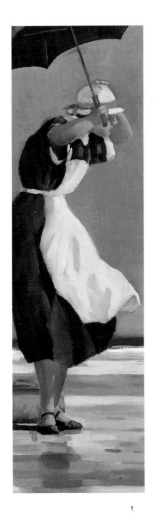

I'm holding my knees together
like some constipated eunuch,
keeping you dry and dancing.
But see if the music were playin for me an Florrie
an my hands an gentle fingertips
supportin her back
as I swings her to and fro
we'd no be crouched and timorous under brollies –

we'd be takin the stormy skies
and the shimmering land,
and weave them into a huge spectrum of colour,
a kaleidoscope that whirls and dazzles.
We'd dance
– and we'd sing you –
into hell.

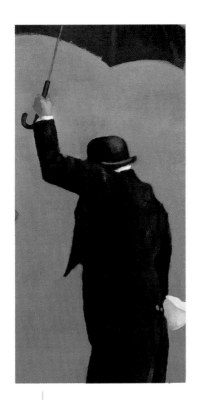

KISS'D YESTREEN

ANON
(Glasgow traditional)

Kiss'd yestreen, and kiss'd yestreen,
Up the Gallowgate, doun the Green:
I've woo'd wi' lords, and woo'd wi' lairds,
I've mool'd wi' carles and mell'd wi' cairds,
I've kiss'd wi' priests – 'twas done i' the dark,
Twice in my goun and thrice in my sark;
But priest, nor Lord, nor loon can gie
Sic kindly kisses as he gave me.

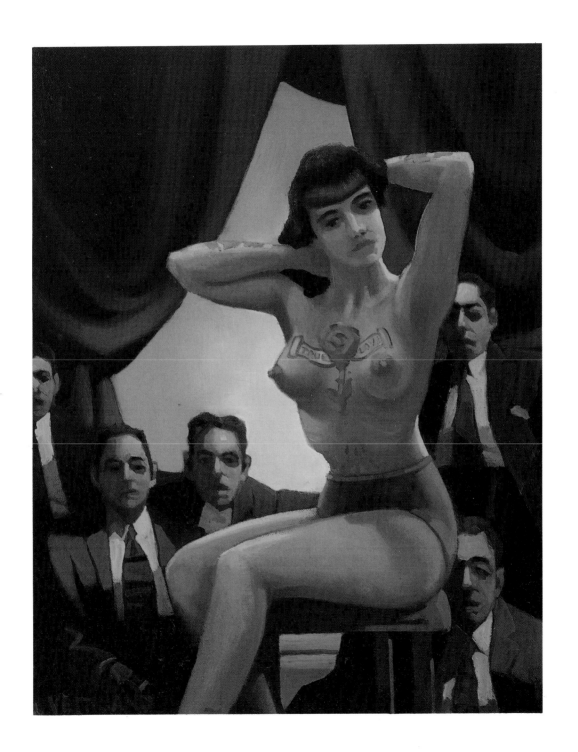

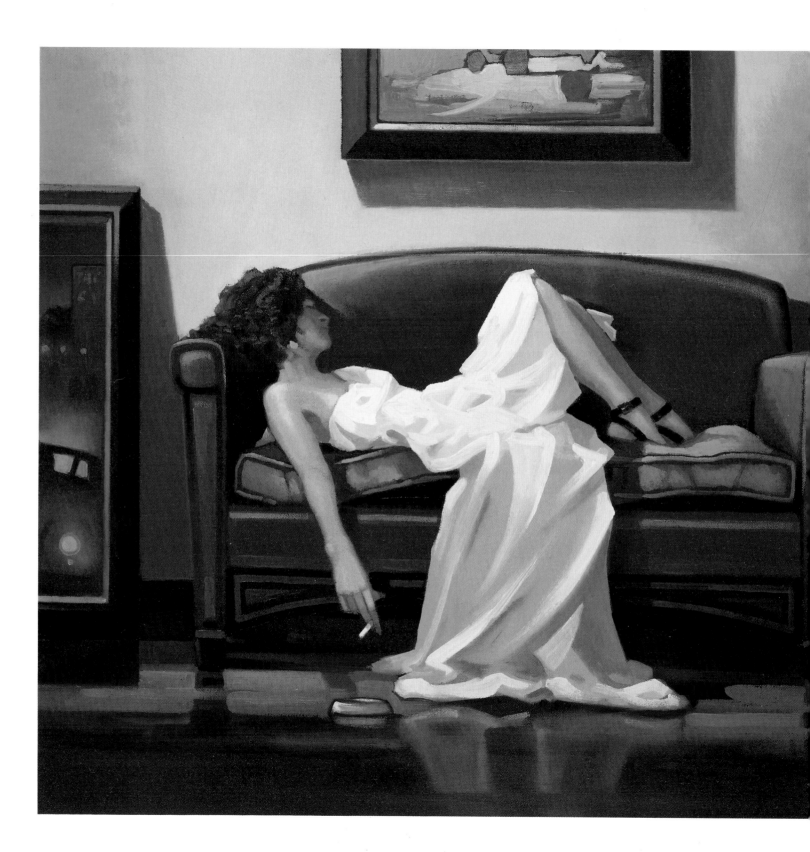

THREE THINGS

ANON

If you would luve and luvit be,
In mynd keep weill these thingis three,
And sadly in thy breast imprent;
Be secret, true and patient.

THE SAME OLD GAME

ALAN TAYLOR

Jack was new to New York but already he felt that he knew it intimately. He'd been here only a day, less than twenty-four hours, but he could see what the writer meant when he said that no one should come to New York unless he is willing to be lucky. And there was something else that writer had said. He said that it was a city capable of bestowing the gift of loneliness. Jack arrived feeling lucky and now he was lonely.

He had checked into a small hotel on the Upper West Side overlooking the Museum of Natural History, having seen an ad in the *Times*. Out of the tourist season and with no conventions in town, hotel rates were plummeting. He got a bed, tub and shower, gas ring and more TV channels than he could count for $39. "But you gotta be here before noon," said the desk clerk.

Jack turned up around eleven, exchanged his credit number for a key the size of a monkey wrench and followed the bellhop into what looked like a closet but turned out to be the elevator. It reminded him of those times when he'd been locked in the cellar at home as a boy. He couldn't remember now what he'd done to be banished there; probably his mother just wanted some peace. In any case, the cellar held no fears for Jack. Sometimes he'd even lock himself in there. He liked the comfort of a shadowless dark. It had imaginative potential; it was there that his first stories began to take shape.

"This way," grunted the bellhop and Jack followed him out of the elevator, down a narrow lobby and into a dingy apartment. The bellhop spelled out what was where like a real estate agent showing a voyeur round a movie star's property. A table lamp flickered on and off. Applause burst momentarily from the television set. Water spurted from the shower. Jack noted a nicotine stain in the bath, below the hot tap. He rummaged in his pockets and handed the bellhop a coin. When the door closed he flopped on the bed and undid his tie.

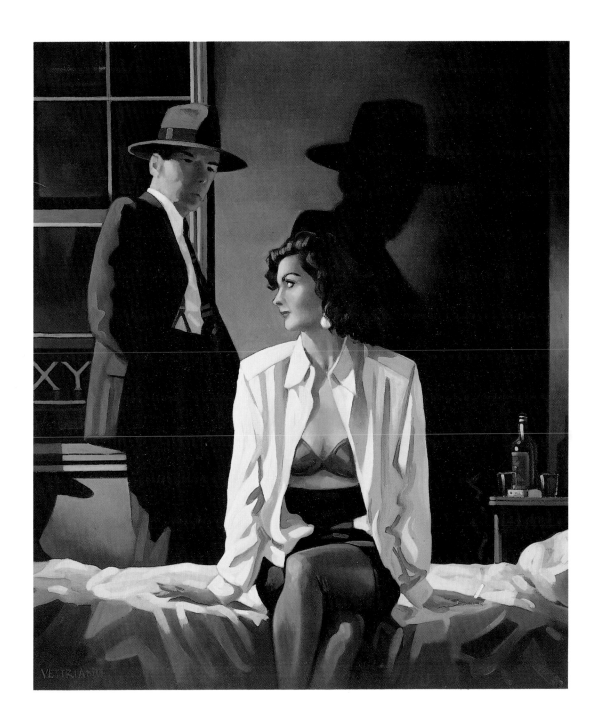

It was dark by the time he awoke, but not the pitch, perfect dark of the cellar. He was hungry and thought about walking up Broadway and getting something to eat, perhaps taking in a show. But really he didn't like shows, with their saccharine sentiments and trite tunes. Instead he took the elevator as far as the hotel's diner. He ordered a coffee and BLT. There was no one around so he took out a packet of Philip Morris, tore off the cellophane and extracted a cigarette. He tapped the cigarette on the packet. He didn't know why. It was his ritual. Maybe Bogart had done it in the same way in *To Have and Have Not*. Didn't someone once say that Bogart was the greatest smoker in the movies? Lauren Bacall seemed to think so.

And her. What about her? "Anybody got a match?" As a line it wasn't much to write home about but when you had Bacall deliver it, it was molten. Anyone could write lines like that, thought Jack, drawing his lips tight on the Philip Morris as if it was a nipple. He still found it hard to think of himself as a writer. After all, what had he written but some poxy short stories. He had started a novel a hundred times. First lines were his speciality. "From the bar came the sound of lives disintegrating." "Emotionally Emily was a witch." "Even swimmers sometimes sink." He could think them up in his sleep.

Once he thought about advertising his talent, offering his services to writers who found it difficult to get started. Maybe he should try hollering his wares from the sidewalk: "Roll up, roll up. Own a first sentence for life. Yours for a dollar a word." Jack's trouble was getting beyond that first sentence. But he must be doing something right. A publisher had written in response to seeing one of his stories in a little magazine and he was scheduled to see him tomorrow.

He pulled again on the cigarette. He kept his writing a secret. He didn't know what the guys he worked beside would make of it. Not much, he supposed. To those guys writing just happened. The idea that you might make money out of it and become famous would never have occurred to them. He'd read a lot about writers and fame, the angst, the glamour: Hemingway standing in a Paris café with a pencil writing *The Sun Also Rises*; Fitzgerald drunk as the proverbial skunk trying to live up to Gatsby; Salinger trying to out-Garbo Garbo. Being a writer

could transform a weedy, stammering wimp into a Mr Eloquence, a highly desirable commodity on the sexual stock exchange. Wasn't it Saul Bellow who said he wanted to become a writer because he'd then be able to make it with beautiful women?

Jack caught a snatch of Sinatra. Not on the juke-box but from a radio, faint and fuzzy, as if it was not properly tuned. He'd heard about a station in Manhattan that played nothing but Sinatra. When I die, he thought, I want the coffin to slide towards the furnace to the sound of *Nice and Easy Does It*. At least it would give his biographer a neat ending.

Pleased with his wit, he called for a Bud. He felt light-headed, almost gay at the thought of the city going on all around him. He was here at last, in New York, a couple of blocks from Broadway, dressed in his best suit, drinking a Bud in a diner with chromium fittings and Frankie for wallpaper.

"You what?"

"Bud," repeated Jack.

The waiter nodded and made a note in a pad. He was a Hispanic. Bud, Jack reckoned, was probably one of the few English words he had. When the beer arrived he drank deep from the bottle. He was turning a story around in his head. It was about a man who loses his job and keeps writing letters to employers begging to be taken on. At first they're business-like but after many rejections the letters become more expansive until he pours out his heart, telling the anonymous recipients his wounded life story; how after his father left, his mother used to beat the hell out of him and how he ran away and never looked back but how in the darkness, with a silent woman by his side, he keeps dreaming of an embrace, of the heat from her body warming his cold heart.

He already had the first sentence. "In a motion that was at once audacious and diffident, she took off her blouse and let it fall to the floor." He was pleased with it, pleased enough at any rate to write it down on the back of the cigarette packet. He could hone it later; he had nothing better to do. After that he'd just have to see how things went.

XANADU

W GORDON SMITH
from his play of the same title

The first scene of a play which uses a brain-damaged accident victim, undergoing experimental therapy, as a metaphor for the Scots – who believe themselves to be of the elect and therefore unique. He is trying to find himself by recalling his national and cultural identity.

The action is set in a blindingly white space which contains a white geodesic dome, a projection screen, a tape recorder, and a mountain of scientific equipment. The man sits in the dome. He wears a white jacket and trousers and he has wrapped his arms around himself as if he were in a straitjacket. He stares out front, not trance-like, but with catatonic concentration

We're roped together, the four of us, and we're so wee we can all stand upright, but we crouch down because we feel more threatened like that, more vulnerable, and we're splashing through the water and slime in our leaky plimsolls, and Angus is our leader because they're his candles. He pinched them out of his family's Anderson shelter. I've got the matches. I've always got the matches. I'm quite famous for lighting fires.

He seems distracted for a moment, as if disturbed by a noise. He struggles for calm, fights back to concentration

Angus in front, Ted and Billy in the middle, and me at the back. The rearguard. The end of the line…*(shouting over shoulder)* Send reinforcements, we're going to advance. What's that? Send reinforcements…*(He hisses it on)* Send three and fourpence…We're going to advance…we're going to a dance…a dance…

He laughs, relaxes, struggles to concentrate again

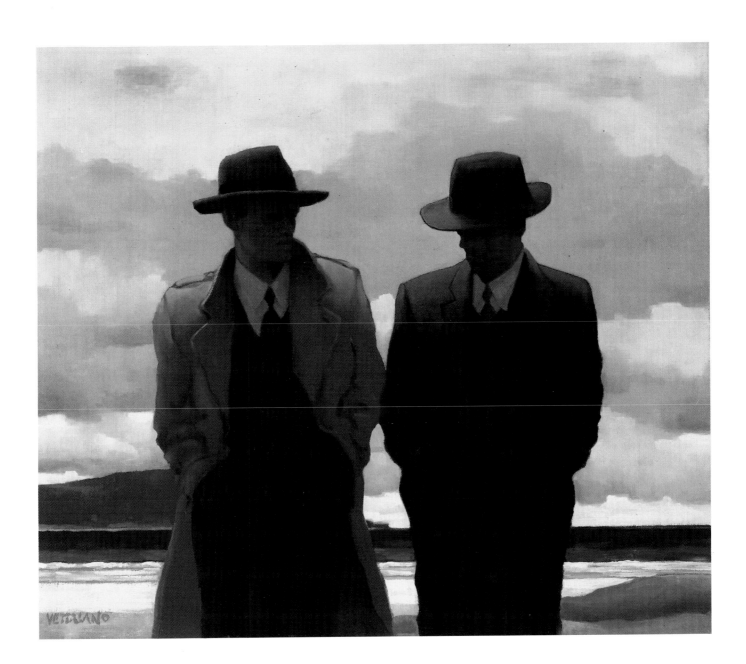

A quarter of a mile of dark tunnel. From Hastie's field where the burn runs to the lip of the quarry. Black. Dripping wet. A half-candle each and hot wax burning your fingers. Haversack heavy. Iron rations. Army marching on its stomach. Two bottles of scoosh, a poke of aniseed balls, a jammy doughnut...Christ, it's hard going on these greasy stones. Feels like uphill.

He twitches his head, brushes away imaginary cobwebs

Steady as we go, steady...keep the rope tight, keep your eyes on Angus's candle. My God, he'll get his arse tanned the next time the siren goes and they all have to sit in the dark. His old man uses the razor-strop on him. The end with the metal bit that fastens to the wall. Still, it's better than the electric chair and Cagney turning yellow and greetin' at the end just to please his pal Pat O'Brien. Wish I could have a chew of Billy's liquorice root. Makes you spit like the panhandlers...Hey there, pardner, m'ol' forty-niner...Makes your teeth the colour of custard. Turns your guts into sugarally water and sends out big long musical farts. One day I managed five notes of *God Save the King*...dear sir, is this a record?

He has been drawn to his feet. He makes to sit again and fumbles for the stool. He always approaches physical obstacles with great caution because he is not sure of their spatial relationship to himself

Angus is Christopher Columbus. Ted can't make up his mind if he's Captain Cook or Ferdinand Magellan. Billy said there was nobody left – that's how ignorant he is – so we told him he was Captain Scott. I'm Marco Polo, on my way to the court of Kubla Khan.

He sniffs, wrinkles his nose

It's like seepage from a cemetery. What if there's a roof fall or an avalanche or a flood? Intrepid, that's what we are..."*In Xanadu did Kubla Khan a stately pleasure-dome decree.*" Ten out of ten for composition and...Christ! Hold on! I...I can't see Angus's candle. What's up, I can't hear you? Stop sploshing around,

Billy. Keep the bloody rope tight. Angus, what's the matter?

He's up on his feet, jinking, turning

My God, a rat! Throw me a stick, somebody. Come on, one of you, I've got it cornered…a big stone then, hurry! It's as big as a bloody cat!

He yelps and grabs his right calf. He flails away at the rat

Oh, my God, it's stuck, its teeth are locked on my leg, batter it one of you…Oh dear Christ it's sore…

He flails away in desperation, then transfers his candle to his right hand and holds it under rat. After a second he whips his head aside, gags, then covers his nose and mouth with his left forearm as he continues to burn the rat

Burn! Burn, you bastard!

He leaps out of the way as the rat runs off. He falls on one knee, examining calf, then limps to stool and sits. A long pause, gathering breath, remembering

They hang around for a while then go on ahead, Columbus and Cook and Scott. They climb down the crumbly cliff and don't wait for me. They go in behind the big bram…*(he falters on the word, but finds it)* bramble bushes and launch the raft we built with orange boxes in the summer and sail out into the middle of the quarry over the bottomless bit where Gracie Telfer drowned last year. She stayed under for ten days, then the rottenness in her made enough gas to float her to the top, all green and swollen, and something had been nibbling at her eyes…

I get to the end of the tunnel and stand on the cliff and look down on the orange raft – it looks like a lentil on a big grey plate. I shout at them and they pretend not to hear. I sit at the cliff edge and kick stones into the water and drink the lemonade, both bottles, one after the other, and leave none for them. Then I stand up and wave my arms about and belch bubbles up my nose and

shout at them again. They don't even look up. I eat my doughnut, then try again. I promise them some aniseed balls if they'll sail for the shore, but they still behave as if I'm not there…I have some carbide in my pocket, out of the old bicycle lamp my dad used before he bought a dynamo. So I put it in the lemonade bottles and it starts to fizz right away with the drops I've left in the bottom, but that isn't enough liquid, so I pee in them both, just a squirt, and screw the caps on quick – well as quick as I can, because I have to go on peeing, having started and all that.

I aim the bottles well clear of the raft, straddling it like a salvo from the big 15-inchers on HMS Hood, and watch them spout up the water then float and bob about. I think they know what to expect, because one after the other they dive off the raft and swim under water as far as they can go without breathing. All three heads just break the surface, then boom! – one bottle – and bam! – the other one – showers shrapnel like it's raining six-inch nails…

I see they're all right, so I just slope off home for my tea. "What's that on your leg," says my dad, looking at my bloody stocking. "Cut it on a nail," says I. He says he can see teeth marks, so I say, all right it was a dog. Whose dog? A stray dog. Where about? Up the road. "Show me," he says, putting on his coat. So I tell him it was the rat, and he moves like the arse of his trousers has suddenly caught fire. At the hospital they're very nice and take my trousers down and pump my bum full of stuff and say I'll likely miss the bubonic plague this time and will probably live…That carbide stuff's deadly. Ted's uncle's a miner and they use it in their lamps. Ted nicked some in the holidays and hid pieces inside balls of soft squashy bread. When the seagulls came to the quarry he threw the bread on the water, the birds swooped and scooped it up, then as they flew away…*(he makes a loud "bedumph" noise)* Just a puff of feathers, like an anti-aircraft shell *(another "bedumph")* End of bird…I couldn't do that.

SYLVANDER AND CLARINDA

ROBERT BURNS

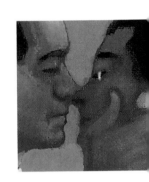

Robert Burns, the ploughman–poet who became Scotland's national bard, extended his reputation as a womaniser and promiscuous buck during his sojourns among the gentry of genteel Edinburgh in 1787 and 1788. He became involved in a passionate affair with a widow, Agnes Maclehose – his Nancy, as he called her affectionately, or his Clarinda in the loving correspondence from him to her; she addressed him as Sylvander. Confined to the house with an injured knee Burns wrote to her on January 14, 1788:

Sylvander: Why have I not heard from you, Clarinda? To-day I expected it; and, before supper, when a letter to me was announced, my heart danced with rapture; but behold, 'twas some fool who had taken it into his head to turn poet, and made me an offering of the first fruits of his nonsense…I am determined to see you, if at all possible, on Saturday evening.

Clarinda: I am neither well nor happy to-day: my heart reproaches me for last night. If you wish Clarinda to regain her peace, determine against everything but what the strictest delicacy warrants.
 I do not blame you, but myself. I must not see you on Saturday, unless I find I can depend on myself acting otherwise. Delicacy, you know, it was which won me to you at once; take care you do not loosen the dearest, most sacred tie that unites us!

Propriety, the baleful influence of a rigorous Kirk minister, and Nancy's financial dependence on her uncle, a Scottish judge, doomed the relationship. Burns

immortalised their parting in one of the greatest love poems in the English language.

AE FOND KISS

Ae fond kiss, and then we sever;
Ae fareweel, and then for ever!
Deep in heart-wrung tears I'll pledge thee,
Warring sighs and groans I'll wage thee,
Who shall say that Fortune grieves him,
While the star of hope she leaves him?
Me, nae cheerfu twinkle lights me;
Dark despair around benights me.

I'll ne'er blame my partial fancy,
Naething could resist my Nancy:
But to see her was to love her;
Love but her, and love forever.
Had we never lov'd sae kindly,
Had we never lov'd sae blindly,
Never met – or never parted,
We had ne'er been broken-hearted.

Fare-thee-weel, thou first and fairest!
Fare-thee-weel, thou best and dearest!
Thine be ilka joy and treasure,
Peace, Enjoyment, Love and Pleasure!
Ae fond kiss, and then we sever!
Ae fareweel, alas, for ever!
Deep in heart-wrung tears I'll pledge thee,
Warring sighs and groans I'll wage thee.

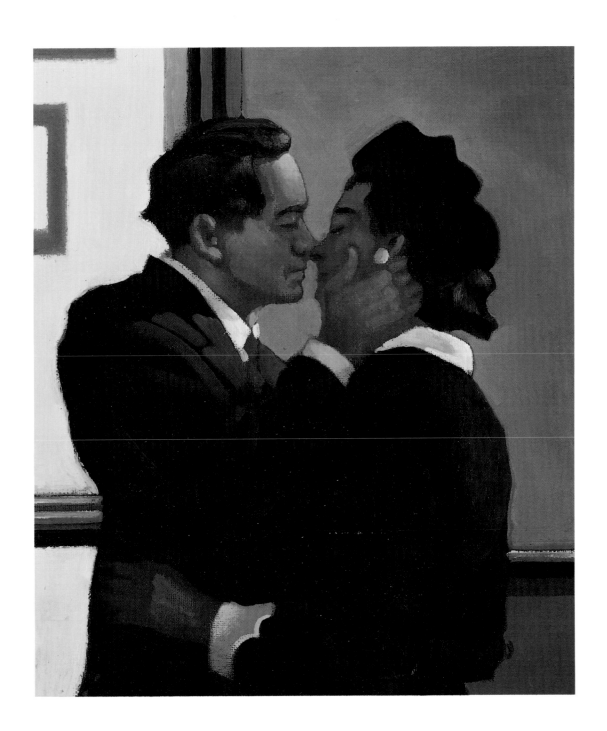

STRANGERS IN THE NIGHT

STEWART CONN

"After all, a fallen angel probably lurks within us all." – Jack Vettriano

Ways of accommodating Dreams vary.
We used to act complicitously,

Nightmare Creatures, caught slithering
across the sill, susceptible to taming;

Wild Things which, once overcome,
enabled you to settle down

in an unmenaced cot, in the belief
they helped you prepare for later life.

Now you press a button to despatch your
 enemies;
Fact or Fiction, simply blow them away.

Adult desires and guilts conversely
have a knack of gnawing remorselessly,

as when seduced by the caress
and thrill of these canvases:

mesmerising comings-and-goings,
scenes of dubious liaisons,

liquescent silk, nocturnal satin,
louche entree to the imagination…

so that at the portals of the gallery,
having deciphered a spidery "mysteriously

troubling and melancholic"
in the well-thumbed visitors' book

you thrust your way, panting, outside
for fear you can no longer hide

that give-away glint in your eye –
or keep Monsters within at bay.

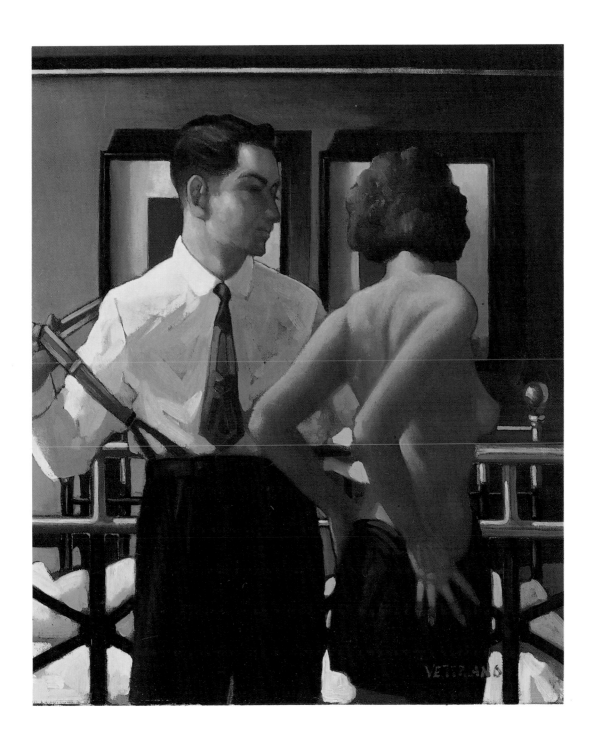

SCREAM FROM A DREAM

JOAN LINGARD
(*from her novel 'After Colette'*)

It was a warm afternoon, without wind. I sat on my dune feeling the heat of the sun on my face. The sea was calm, too. The waves came purling in and were sucked quietly back, and came rolling gently in again, and I could have almost fallen asleep. They were down in a dune a few yards away, hidden by whins. They were murmuring to each other, softly, softly, and the sound was like the rippling of the waves.

And then Amy screamed. It was the scream from my dream. Calling for me. A piercing scream, ending on a dying fall. I leapt to my feet and, slipping and sliding in the soft sand, lumbered across to their hollow. I looked down, and saw a tangle of white legs. He was on top of her. A fine spray of sand rose around them.

"What are you doing to her?" I yelled, and flung myself down the sandy slope. I caught hold of his hair and pulled. With a swift turn of his shoulder he repulsed me. I went flying backwards into the sand.

"I'm not doing anything to her, you silly little fool! She wanted it!"

I struggled up. I backed away from him. Then I fled through the sharp whins, skirting the barbed wire, grazing my knee, not noticing the jagged gash until later, when it began to turn septic and had to be bread-poulticed. I went down on to the beach, to the firmer, darker sand close to the water where my feet would find a surer touch and my legs could move faster. Amy caught me up at the far end by the rocks. Her hair was dishevelled, her clothes in disarray. She pinioned my arms, forced me to stand still, to look at her. My teeth were rattling in my head. I could feel grit in my mouth.

"Now, listen!"

"I don't want to listen."

"You're too young to understand –"

"People always say that."

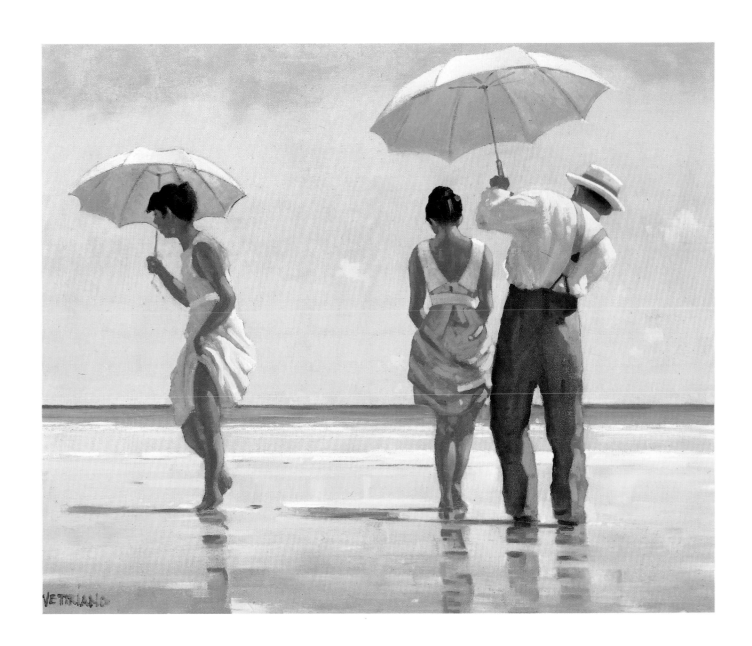

"Maybe I shouldn't have done it, but he's going away." She sounded feverish. "It's wartime, you see. It's different. He's going to France, he might get killed."

"I hope he does!"

"Don't say that!" I thought she was going to slap me. "I love him."

I said nothing then.

"And he loves me."

"But he hurt you."

She released me and turned to gaze out over the expanse of sea to the horizon. The wind had risen a little. White frothy waves were running over her bare feet; the tide was coming in. There was sand on the back of her hair. It clung to the strands, dulling the colour. I rubbed the red marks on my wrists. "Maybe it wasn't exactly what I expected," she said. She seemed to have forgotten me; she was speaking so quietly that I could scarcely make out what she said above the sighing of the sea. What had she expected? What had they been *doing*? "He loves me. He says he's never met a girl like me before."

ODERICK

ANON
(From the Gaelic)

Roderick, Roderick,
Roderick of yonder dun,
Thou art my mirth
and my merry music,
Thou art my rosary
and the comb of my hair,
Thou art my fruit-garden
wherein are apples.

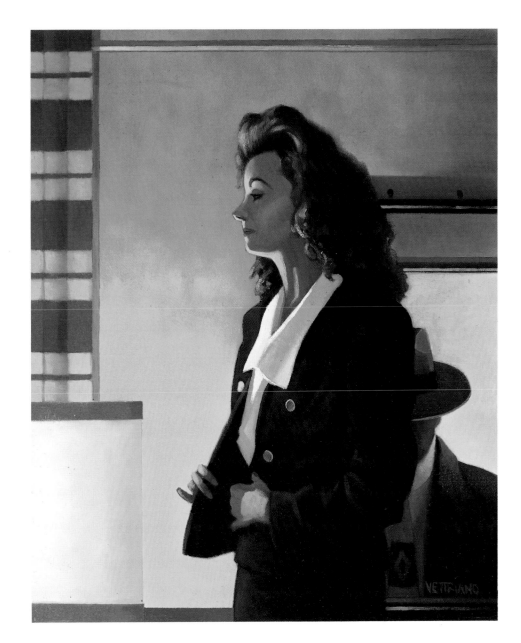

LITTLE ITALY – WORDS FOR A SONG

BENNY GALLAGHER

Almost five years on
Almost to the day
The last piece of the puzzle
Finally...fell in place

Jack Vettriano
Has to take the blame
His paintbrush oils and canvas
Transported me back there again

Little Italy
Is in Glasgow and Edinburgh
Ayrshire and Fife
It's a café, a restaurant
A "poke"of chips
Or just a plain ice

It's Macari's in Largs
On a winter's night
Where rock 'n' roll purists
Unfettered by tourists
Sip cappuccino...and
Select all their heroes
On the jukebox
At "a tanner a time"

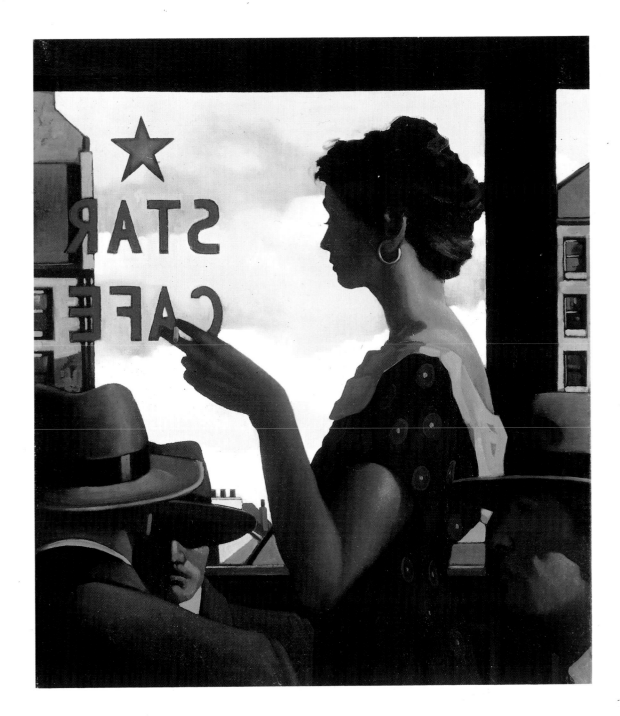

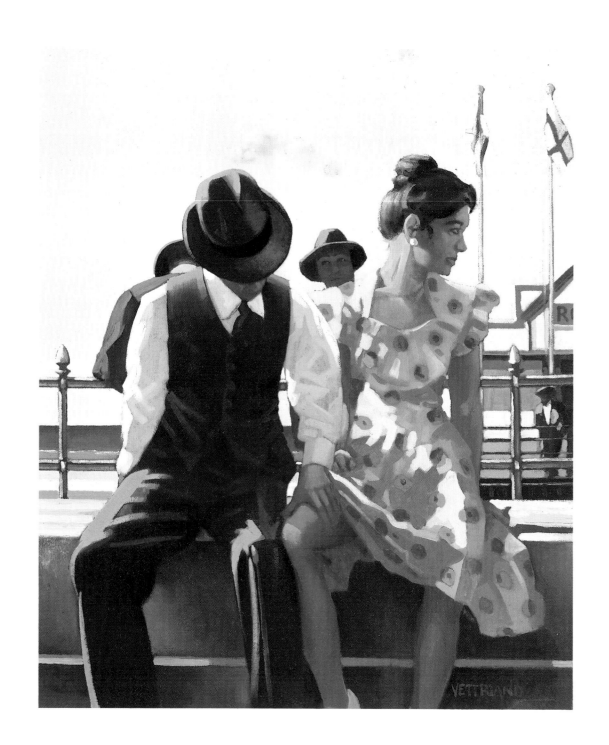

Little Italy
Is Sundays in chapel
The occasional snore – invariably
Induced by the sermon –
Then on to Nardini's
With its 50s decor
Where seaside girls
Play havoc with the hormones
And flutter eyelashes
Therefore ensuring
Pursuit along the prom
As far as The Moorings

There among the cut glass scenes
The serious business began
As young women perfected the time-honoured art
Of how to handle a man

Little Italy
Is an Oscar Marzaroli photograph
It speaks – yet makes no sound
It's Bruno Belli – who canoed up Largs main street
And ran the best chip shop in town
No strangers in a strange land
Nature's natural restaurateurs…
And erstwhile chaperones
Condoned assignations
Quarrels and flirtations
As we stumbled blindly through childhood
Emerging – none the worse for wear
Fully grown

Little Italy
Is Scozzese-Italiano thick as blunt knives
And none would mourn its passing more than
The sweethearts and cohorts
Who heard it as part of their lives

THE MAIN ATTRACTION

JOY HENDRY

Just who the fuck dis she think…
She's supposed tae be waitin…
Wummin these days…

I slouch behind the pillar
and light a cigarette
just behind her,
loungin on the other side,
close enough tae touch…

Shit!
I can feel her throbbing through the wood
her arms loose on the railing
her crimson leg shockingly akimbo
Darin me
Tauntin me
Ma eye is burnin a hole in ma brain

But I can't.
I cannae
move.
Not a muscle.

Look at her…
Slut!
Darin the whole saloon
tae step up sprightly,

Come up here, boy
See what you can
Manage…

But her flaccid gloves might sting ma face
and her cigarette
droops frae casual fingers
like the end o ma expectations.

I
can't
take
ma
fuckin
eyes
affa her!

Sumbody shoot her!
Please!

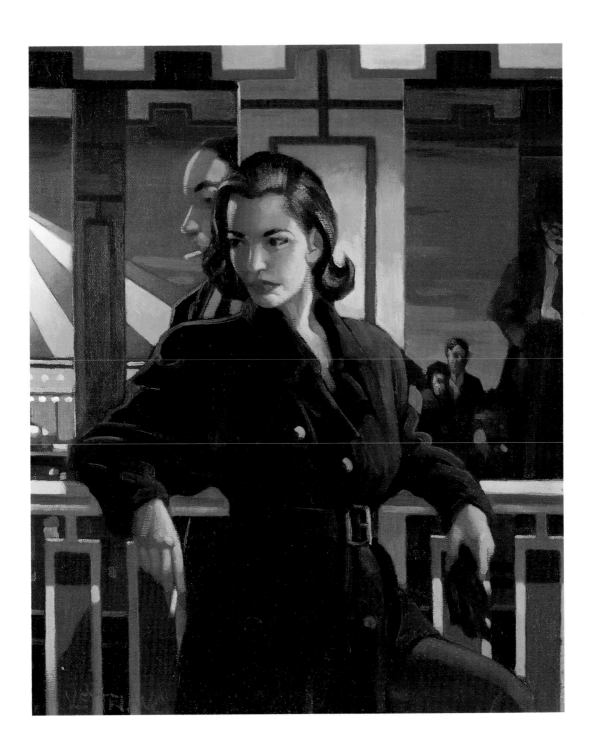

BETRAYAL

RON BUTLIN

Do you remember who made love an hour ago?
They lived for too short a time – and so

before leaving I will pull you close:
your lips will press on mine
reprieving a lifetime, even
for the length of a kiss.

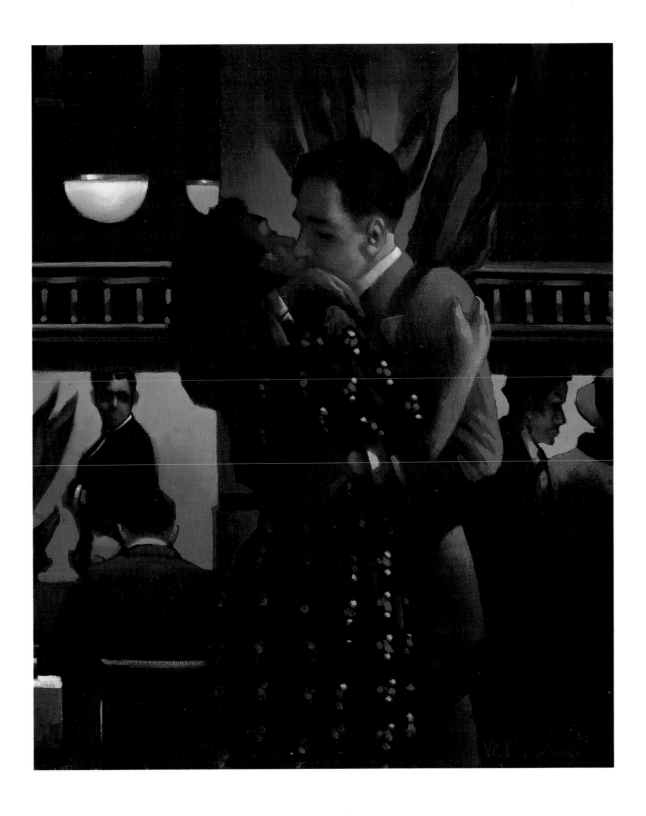

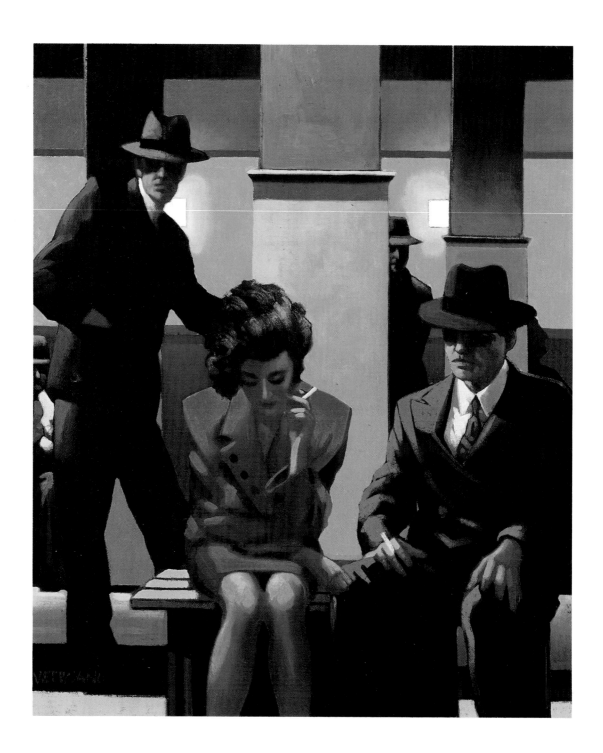

THE WUMAN TAEN IN ADULTERIE

WILLIAM LAUGHTON LORIMER

Jesus gaed awa tae the Hill o Olives.

Gin day-daw he wis back i the Temple, whaur the haill fowk cam til him, an he leaned him doun an taucht them. Belyve the Doctors o the Law an Pharisees brang til him a wuman at hed been fund committin adulterie an set her there afore them aa. "Maister," they said til him, "this wuman hes been catched i the verra ack o committin adulterie. Moses laid doun i the Law at siclike weimen wis tae be staned tae deith: what's your thocht?" This wis a girn; they war seekin something tae faut him wi. But Jesus loutit doun and begoud scrievin on the grund wi his finger. Whan they keepit on speir-speirin at him, he strauchtent himsel an said tae them, "Lat him amang ye at hes ne'er sinned nane clod the first stane at her." Syne he loutit doun again an gaed on wi his scrievin.

Whan they hard what he said, they gaed awa, ane an ane, beginnin wi the auldest, till he wis left himlane wi the wuman ey staundin thair forenent him. Syne he strauchtent himsel an said til her, "Whaur ar they, wuman? Hes naebodie condemned ye?"

"Naebodie, sir," she answert.

"Nowther div I condemn ye," said Jesus: "gang your waas, an frae this time forrit sin nae mair."

Gospel according to St John, Ch. 8, translated into Scots

CHAPTER EIGHT FROM A NOVEL IN PROGRESS

ALAN SHARP

A letter came for Uncle Matthew. It was, in their house, something of an event. Not because they never received letters but because they never received letters that were not immediately identifiable. Mrs Anderson picked it up behind the door and brought it into the kitchen. She looked at the long, faintly grey envelope.

"Who's writin' tae Uncle Matthew?" she asked.

Davie looked up. "Open it'n hiv a look."

"Ah will not." She walked to the corner window and held it up.

The envelope had a name embossed on the back flap. Davie, sensing her curiosity, joined her. Mrs Anderson tried to make out the raised lettering.

"Ah'm blin' withoot ma glesses," she said.

"Gies a look," and she handed him the envelope.

It impressed Davie. The envelope was stiff and the paper had fine stripes running through it, and it had a certain weight in his hand and its shape was pleasing with the feel of the pages within, folded but full. He read the embossed printing.

"Mirren Lorimer. 12 Acton Terrace. Bath." and he looked at his mother, "Bath's in England," then turning the letter over he saw the postmark, "bit it's postit in Greenock."

Mrs Anderson took the letter from him and put it on the ledge of Uncle Matthew's shaving mirror. Davie noticed her face had gone the way it went when she thought she detected an argument starting after the News on the wireless, a kind of stillness and a slight set of her lips.

"Is Mirren a man's name or a woman's?" Davie asked.

"It's a wumin's."

Davie looked at the writing on the envelope. The letters were tall and slender and the ascenders, the 'h' and the 'l' had little coifs on them, little curls, and the

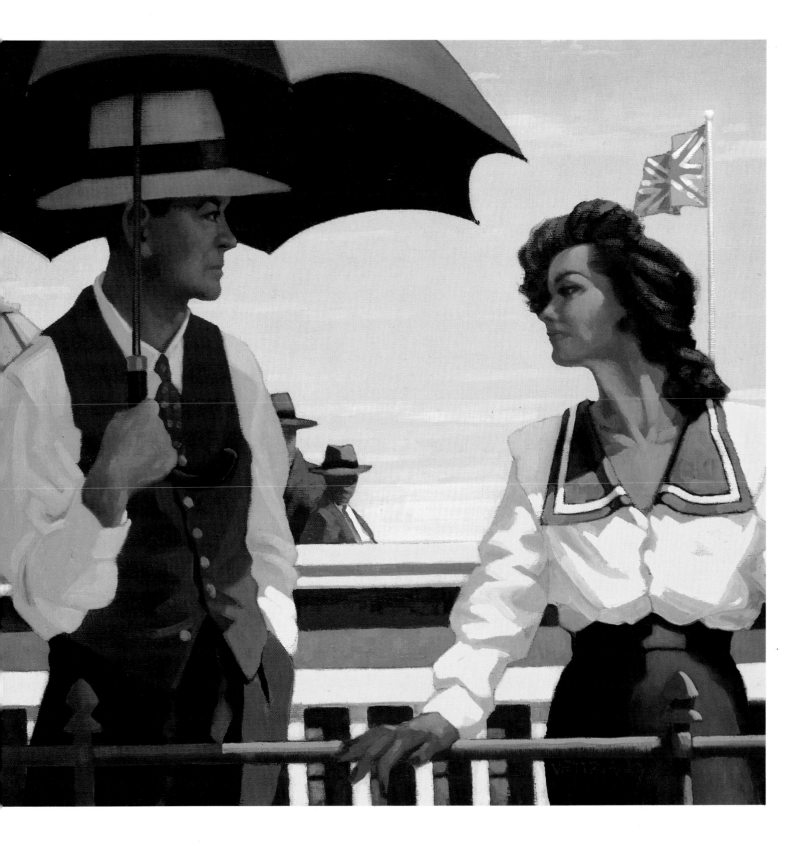

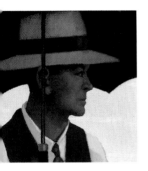

ink was a colour he had never seen other than in Senga's eyes, violet blue, and suddenly, quick as a knife, he wished the letter was for him.

"How d'ye know?" he asked.

"Ah jist know," she said and went back to her sewing.

Although nothing more was said the letter held the afternoon in thrall, waiting its owner's return from his walk. Up the Mirren Shore, Davie thought, this echo adding further mystery to the pale oblong beneath the mirror. Mirren. What manner of name was that that it could belong to a stretch of shoreline and a lady from Bath, England, and still mean nothing. He noted that when the outside door opened his mother's head came up and the treadle of her machine paused its rocking.

Uncle Matthew came in and went straight to the fire, holding out his hands, still in their mitts, to its comfort.

"A bitter wind aff the watter," he said, looking down at the flames. "Ah hope Sam's no' on an ootside squad the day."

"Yiv got a letter," Mrs Anderson said, ignoring this regard for her husband's welfare, an omission which alerted Davie further to the extent of his mother's curiosity. Normally such a remark would have drawn forth considerable concern.

"Aye, it'll be fae the pension," Uncle Matthew said without turning round.

"Naw," Mrs Anderson said, quicker than she intended, then trying to conceal her haste, "Naw, it's not wan o' they ow broon envelopes." Uncle Matthew looked at her.

"It's no' the pension," Mrs Anderson said.

"Well," said Uncle Matthew, "Ah wonder what it is." Taking this as his cue, Davie went to the mirror and fetched it.

"Rerr ink," he said, handing it over.

Uncle Matthew stood, his back to the fire, looking at the envelope. Then he peeled off his navy blue mitts to reveal his large purpled hands. The envelope seemed strange in their grasp. Davie felt an urge to remove it and say something like, "Better warm your hands first," but he didn't, just stood waiting. The hands revolved the envelope once, twice, then a third time. Davie looked up in time to see Uncle Matthew say, almost to himself,

"Oh my."

"Whit is it, Matt?" Mrs Anderson asked. "Zit bad news?"

He didn't answer, just continued to stare at the thing in his hands. Then he turned and put the letter on the mantelpiece, against the clock.

"Zit bad news?" she repeated.

"Naw, Ah widny think so," and then to Davie and his mother's astonishment, he went out of the kitchen without another word.

They stared at each other and then at the letter that remained behind, a thousandfold more intriguing than it had been a moment before, and, united in their frustration, laid pretence aside, coming close to talk in bated voices.

"Did ye hear the way he said, 'Oh my?'" Davie nodded, for he had. "He knew who it wis fae the minit he clapped eyes on it."

"How did he no' open it, though?" for Davie could not imagine such restraint, he, who had half read his mother's *Red Star* on the way back from the Post Office.

"He's gie deep is Matt McClure. Ma fether aywis said he never knew whit wis goin' on in his heid an' he worked alongside him fur thirty years."

"Away then an' tell him wir dyin' tae know," Davie said.

His mother looked at him, getting ready to say in her indignant tone, "Ah will not," but instead she said, "Away you an' tell him," and they laughed, conspiratorial.

They had to wait nearly half an hour for the next act. Uncle Matthew came back into the kitchen. He was wearing a clean grey shirt, without a collar and he proceeded to shave in front of the mirror, going through the whole solemn ritual; newspaper torn and on the hook, razor folded out of its long bi-valve body, stropped, thumbed on the feathery edge, the lathering of the brush, the whiting of the face and then the precise, three-cornered dance of steel on skin, and the magical emergence of the younger, pinker Uncle Matthew. After he had gone over a second time for patches missed, he rubbed some bay rhum on his hands and slapped his face briskly, gazed at the new born face, and said to it, "Silly auld fool." Then he put all his tools away, rinsed the brush, burnt the paper with the grey scallops of old soap and took his letter and went back into his room.

"That's no ferr," Davie said.

Mrs Anderson shook her head. "He's daein it deliberately, the ow devil."

"Think he'll tell us efter he's read it?"

His mother made a sound in her nose that needed no further text, but she added it nonetheless. "Be the furst time if he did. He's a closed book, that yin."

For Davie this could not be. Not when the book had such a binding, such a fragrance from its pages, such a sense of a story untold that craved telling. The idea of Uncle Matthew's privacy was, to be sure, an issue, but Davie could find nothing in God's decrees that forbade wanting to read your Uncle's letter. Covetousness was the nearest and even that was wide of the mark. He wasn't covetous. He was curious. "Thou shall not be curious about things that don't concern you." God didn't say that, not in as many words, and anyway, who was to say what concerned him. And what was concern? To lie burning with a fever to know who and what Mirren Lorimer was, to long to follow the stately dance of violet words across grey pages, for surely the pages too were grey and stiff and with a faint grain to them. Yet it was wrong, that too was clear, for if it was not why could he not ask Uncle Matthew what was in the letter. He wrestled it to sleep several nights, exhausted by the inability to triumph over conscience, until, waking in the midmost night to hear Uncle Matthew snoring away in the darkness, he surrendered, all at once, to Satan's whisper, "He must read the letter because he must." There was no other issue involved. It made him shiver, the nakedness of it, the simple, wilful insistence of self, cutting through the miasma of moral uncertainty. At once relieved and fearful, he burrowed beneath the bed clothes, resigned to his freedom.

Uncle Matthew's chest of drawers stood four shelves high, a walnut veneer with a bowed front and brass and porcelain handles. Davie had seen it open on various occasions but had paid little attention to the contents. He drew up a chair and pulled out the top drawer. It opened easily. There was an odour of embrocation and a wilderness of patent medicines in bottles and round waxed cartons entitled inscrutably 'The Medicine' or 'The Ointment' or, simply, 'Tablets, take as directed.' There were other things, used and re-rolled bandages, a wide elasticated belt with hooks and eyes and, lying on its side a bottle of whisky with an unpronounceable name thick with 'chis' and 'uis'. It was not the drawer where such a letter would be kept.

Neither were the next two, one of which held underwear and other shirts. He felt among the shirts briefly, the colour of some of them echoing the envelope

but such was his anxiety at being caught it was but a scant search. The bottom drawer when he pulled it out, however, gave immediate hope. There were all manner of things, none of them clothes or medicine. Bundles of papers with official writing and seals affixed. There was a wooden model of the fish plate which had brought Uncle Matthew his modest fortune, and a machine for slicing plug tobacco that had brought its inventor no reward whatsoever. There were razors and binoculars and a box Davie knew contained a sextant, mysterious beyond geometry. And there was, at the back, a box of black wood with yellow flowers inlaid. Even the sight alone told Davie he had come to the source. Opened, it revealed, topmost of the contents, the letter.

For a moment he hesitated, a last pale chime of guilt ringing. But it was far, far too late now. He picked up the envelope and beneath it there showed a photograph. The lid of the box was almost closed before it registered. He looked again. It was in the sepia of bygone times and mounted on board, dark grey, worn round at the edges. It was of a man and a woman. The woman was young, or youthful, and she wore a kind of sailor suit, or at least the neckline of the blouse looked like a naval tunic. Her hair was wide and parted, falling thick to her shoulders and the way her head turned to look at her companion, the tendons of her throat drew taut and long. She looked at him without a smile, but all of her attention went to his face. It was only after a moment's immersion that Davie came to the surface and recognized that the man was Uncle Matthew. In a way he could not begin to comprehend, the woman was more familiar to him than the figure that stood, almost unidentifiable, shorn of untold years and his moustache, holding a large dark umbrella and staring, inconsolably, at Mirren Lorimer.

23 Eldon Street
Tuesday, October 28th
My dear Matthew, how will I begin a letter left unwritten for thirty-five years. It is thirty-five is it not. I think we saw each other once since then but as one of us was on a train and the other on another platform it is scarcely proper to call it a meeting. A glimpse at most. So let me tell you why I am here, back in Greenock. My mother, "The Mother", died two weeks ago. She had been with me in Bath for the last year, suffering terribly from a malignancy that reduced her at the end

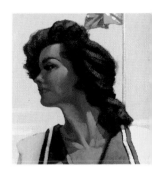

to a hank of hair on a few bones. It was quite terrible and I was truly glad when it ended. I cannot say the same for her. What might have been in someone else a kind of courage was in her simply another example of her ruthless determination to have things her way. Also, beneath that awful armour I sensed a fear which, could she ever have acknowledged it, might have endeared her somewhat. You will probably not be surprised to learn that she derived very little comfort from her religion. Her Crowbar, as you once called it. In fact, I don't think I heard her utter God's name once with any religious feeling throughout the whole ordeal.

And yet Matthew I wept when she died. I wept for days. It amazed me that I had so much to weep about or so many tears to weep with. But as each tide ebbed, another came and I gave myself over to them as I cannot recall ever having given myself over to anything since I knew you. I wept for a hundred things I had forgotten, for broken dolls and torn mottos, for pets that died and birds whose wings would not mend. I cried for my brother Bill, and my dear sister Essie who only died two years ago, worn out from waiting for Mother to go first. I cried for Dad, for dear, gentle, helpless, sad old Dad, and most of all, Matthew, I cried for us. Oh, Matthew, how I wept for you and me...

I wonder if you remember us. Of course I know you recall, that you have not forgotten, that you are not scratching your head and saying "Mirren, who?" But I also know how hurt you were and sometimes we deal with such pain by forgetting. There, I have given away my own secret by imagining it yours. I had forgotten, denied, you would say, so much, but it was as if with her death a stopper had been withdrawn and up out of me came memories more vivid than experience itself.

I remembered when first we met on the Glenluce Pier and how my breath caught when you stopped and looked at me and I looked away, down, and how clear the water was beneath and the fishes, little fishes, shoaling and the thought came to me, "If I fell into this water, would this man put down his tool box and leap in to save me?" Me, little prim Mirren Lorimer who had never in her life until that moment had a thought that the priest could not have read out at Mass. I remembered the day, the stolen, golden day, we walked from Ardnaha to Pulvey and our hands were never apart, save when you would take mine by the wrist and flap it dry. What a day of days! Even as I wept for it, and all the others

like it, long gone now and shadowed by what lies between, I still felt as we felt then, that the sun would shine on us always. Is that not a foolishness from a woman close to sixty. And I remembered our secret meetings in the Bay Hotel and the table by the window when we'd drink our Big Sailor and watch the river. And more and more I remembered. No end to remembering.

I came back to Greenock to see to mother's things. The house is full of them and at first I could only think to sell them, or give them to St Mary's, and return to Bath. But a few nights at the window watching the Clyde made me in no hurry to return. Bath is so inland and so very "perjink". Rather like me now, I would not but wonder. But there is one part of me that is not and that's the part writing this letter. I know it is a terrible intrusion to come so abruptly from the past into the present. But here I am. If you would care to visit, I shall be at the house on Saturday.

Yours,
Mirren

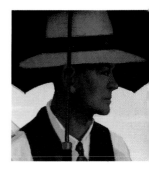

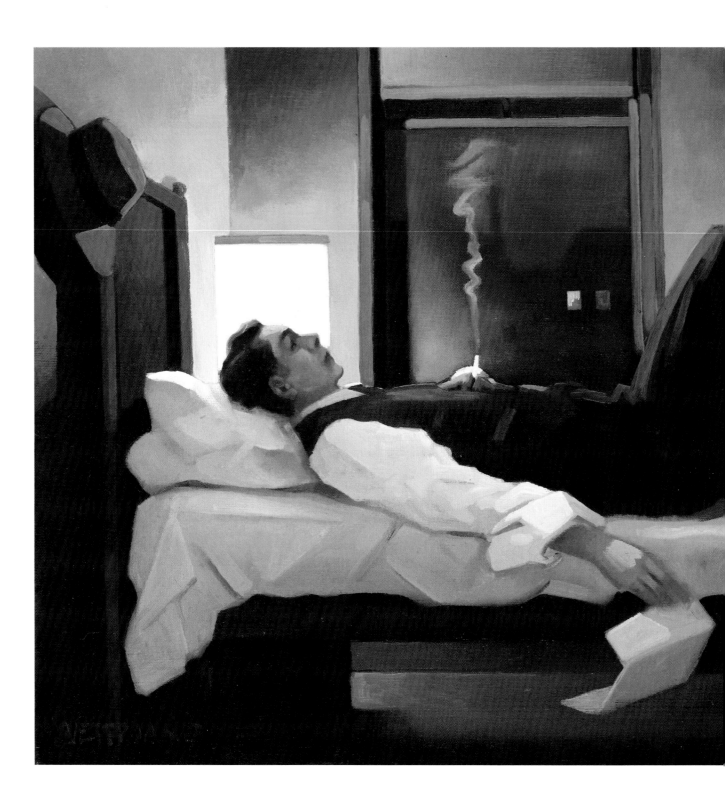

HEARTBREAK HOTEL

IAIN CRICHTON SMITH

You have left me in this prison,
formal and dark.
There is a yellow light somewhere,
as if from a mirror or door.
My hand seems to have lost its vigour,
your letter hangs from it like a late leaf.
A long sentence lies ahead of me.
How is it such a formal jail
can suddenly become so real?
Yet freedom at one time was near.
Into what distances I stare!
Condemned, I now lie on a bed.
Condemned, one hand beneath my head,
while the world comes to a sudden halt,
formal, glacial and bereft.
The letter almost leaves my hand.
My hat hangs on a final stand.

THE AIRPORT

BERNARD MacLAVERTY

Two Americans sat at an enamel table talking loudly, ignoring the chimes and flight announcements. Both men were bald and fat. The smaller one was the older by far, could have been the big one's father. His head was freckled with age spots and his white hair at the sides was as short as suede. He took out his wallet and produced a sheaf of English notes of different denominations. He had a big cigar stub in the right-hand side of his mouth. At no time did he remove it – not even to talk – his upper lip was the shape of a sickle, clamping on it.

Behind, a trolley was piled high with aluminium cases, overcoats and hats. The younger one took out his wallet and they talked notes. Then he got up and went to the trolley. From a coat pocket or somewhere he produced a paper cup with the word LIGHTNING written on it in red-white-and-blue. He sat down in a special way on the enamel stool. He straddled it, then with one hand hooked between his legs he lifted the crotch of his trousers and lowered himself onto the stool by bending his knees – like he was wearing a truss. Once down he produced a small tin and opened it. He hooked something black out of it and popped it in his mouth. After a while the big one lifted the paper cup and sipped from it.

He produced his wallet again. Some money changed hands. The old man looked closely at the denomination of the notes he'd been given, held them up to the light. The other one sipped again from the paper cup – yet it wasn't like real sipping. He raised the cup to his mouth but did not tilt it. It was as if he was about to drink then was changing his mind at the last second.

He was chewing tobacco and spitting into the cup. He spat like a rabbit – if such a thing can be imagined – lifting his top lip and squirting downwards between his top lip and his teeth.

When their flight was announced the small one put on a brown trilby. The big one eased his head into a white stetson, then hooked a finger inside his mouth – between his gum and cheek and dropped something into the paper cup. He had

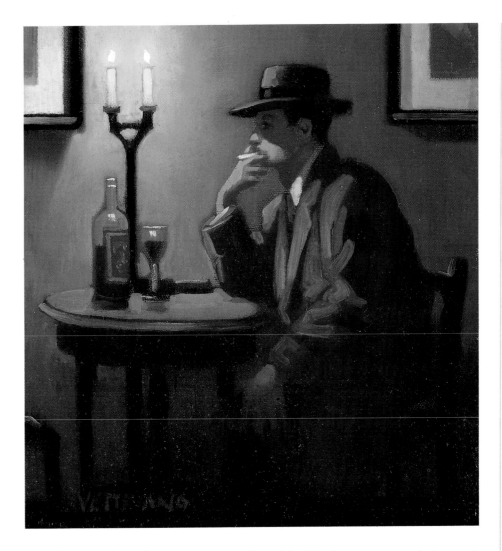

a final spit and set the paper cup on the table. Black scree covered the cup's inside wall. They gathered themselves and the small one led off twirling a gold topped cane which he didn't lean on, but walked with. The big one pushed the trolley after him round-shouldered, shambling, looking out from under the brim of his stetson.

A woman in a torquoise overall, wiping table-tops and tidying, worked her way towards the place the Americans had just left.

THE STATION

BERNARD MacLAVERTY

The heat had gone out of the sun. People had begun drifting away from the beach and stood waiting for the train back to the city. There was quite a crowd now. The sun was about to set and the light was yellow.

The station had little or no platform. The central island and the tracks were all on a level. To enable passengers to cross from one side to the other sleepers had been laid between the rails. A number of trans-continental trains hurtled through with a deafening roar and a hot wind which ruffled those waiting for the local train.

A man in his early twenties with a heavy black stubble on his chin came onto the platform. He wore a yellow T-shirt and had no laces in his black canvas shoes. He took short steps, pushing his feet along the pavement, barely lifting them – like a child playing trains, but slowly. All the time he grinned and made a grinning noise and held his hands out in front of him as if begging – but he was not interested in money. People tried to ignore him. As he approached they turned their shoulders a little more towards their companions. Their conversation became more intense. A girl standing on her own made a decision and moved towards the notice board as if to look at train times.

Three young girls, barely into their teens sat on the central island. They wore shorts and brightly coloured tops. They did not see the boy cross the sleepers towards them. People seemed concerned that the boy should complete his journey across the track before another train went through. His laughing and grinning continued all the time. When he came up behind the girls they looked up. They giggled, then seemed concerned, then laughed again. The youngest one stood up and ran, covering her laughing mouth with her hand. The others followed across the tracks not bothering to hide their laughter and embarrassment. The boy turned slowly and clumsily, his arms outstretched and followed them. The watching crowd registered – it's girls he's after – and became more

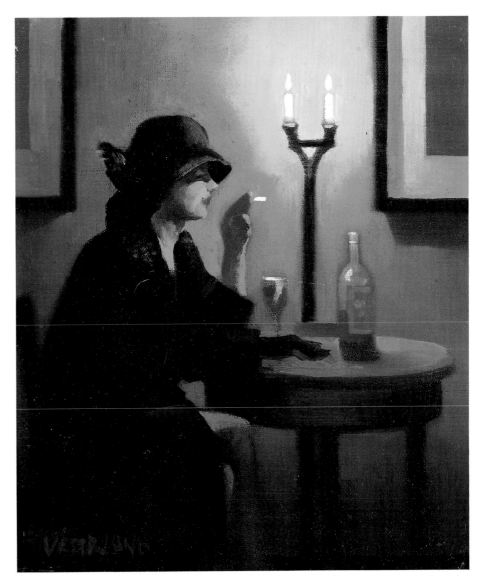

tolerant. They even allowed signs of their amusement to show – an eyebrow raised, a smile, a nod which indicated the boy to someone who had not yet noticed him – for there were some who were too engrossed in their own company to look up.

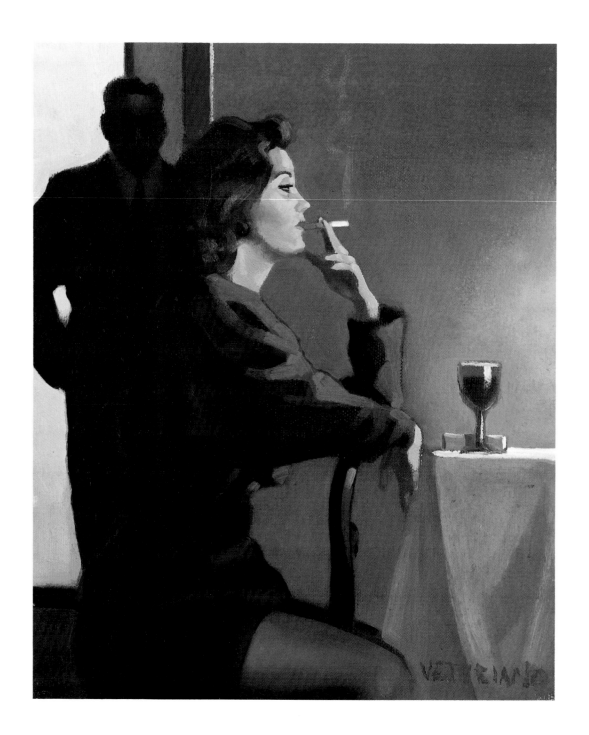

SOMEONE TO WATCH OVER ME

SUE GLOVER

I'll not harm a hair of her head.

Picked her up off the street, put a shirt on her back. Paid over the odds for the tint and the perm. The bracelet, the nylons, the powder, the paint. Showed her off round the bars. Hard work, all that.

No – I'll not harm a hair of that head.

I'd not put a mark on that flesh.

Tried and tasted it well, taught a few fancy tricks. Real sweetness at first – even felt it myself. Fed her only the best. Decent dope, strong drink. But trust can turn sour, day in, night out.

Still – I'd not put a mark on that flesh.

No need for a threat or a slap.

No need for that now there's the kid – sleeping through there in the other room, thumb in his mouth, milk on his chin. She won't leave the kid, and I won't let him go. Mother and baby – the lock and the key.

No need for blows now, not a hair, not a mark.

I look out for them both: my girl, my kid.
Shut the door, Mummy's working.

I'll not harm a hair of her head.

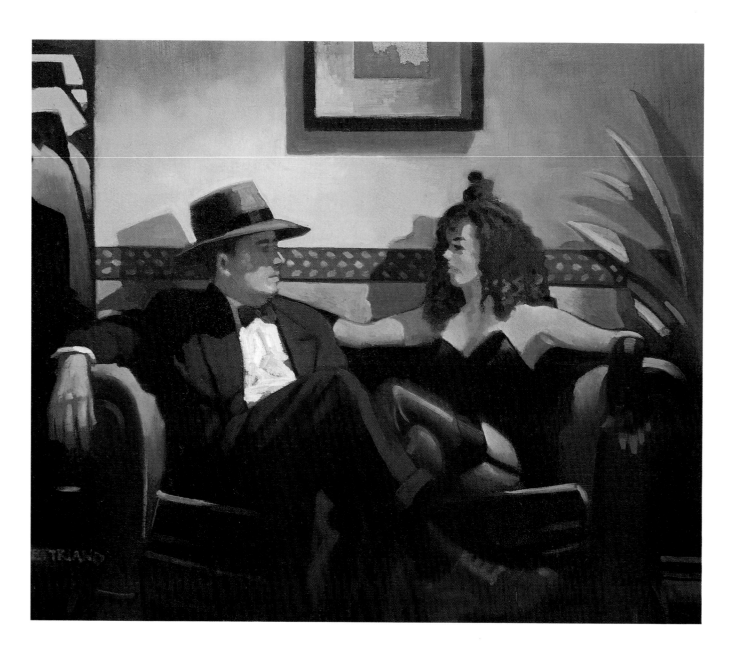

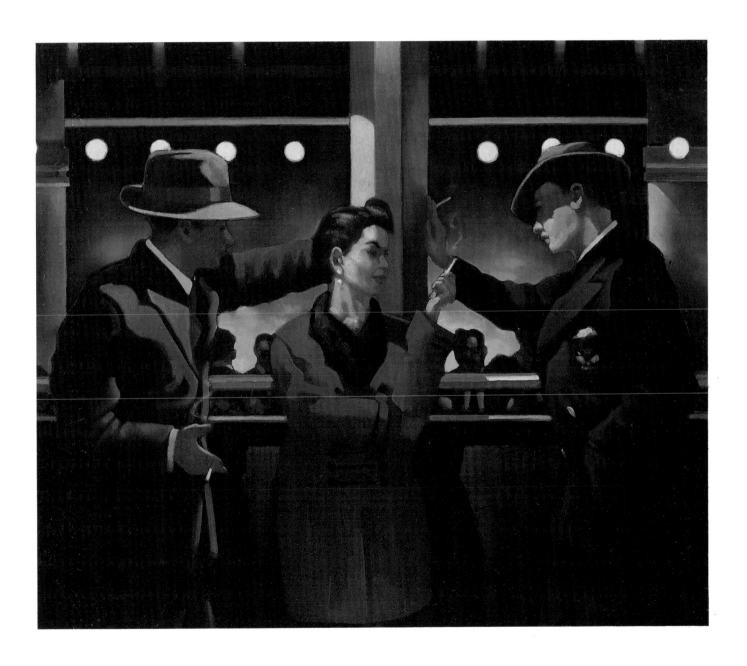

THE FLOWERS OF EDINBURGH

At the height of Edinburgh's eighteenth-century Golden Age, the High Street was "inhabited by a greater number of persons than in any street in Europe." Between Edinburgh Castle and the Palace of Holyroodhouse lived no fewer than sixteen earls, two dukes, seven lords, two countesses, thirteen baronets and seven lords of session. There were many laudanum dens, taverns and houses of pleasure. In 1775 a directory was privately printed as a topographical inventory of the principal brothels and a consumer's guide to the available delights.

MISS BLAIR, AT MISS WALKER'S
This Lady is about twenty-two, tall, red hair, good teeth and eyes, and very good-natured. She also understands her business extremely well; for she will, at any time, as the song says, "go twa go's up, for one go down". And when the sport is over, she will soon make nature revive, by a peculiar art that she is entire mistress of.

MISS KATTY GRANT, AT MISS BEESTON'S
This Lady is little, black hair, round faced, tolerable good teeth, and about twenty-four years of age. She is extremely sly and artful in her devotions at the Shrine of love, and has a great deal of pretended modesty, which is very disgustful to most people. If this Lady thinks shame of her profession, we would advise her to give it over. Notwithstanding, when she is engaged, she does her business very well.

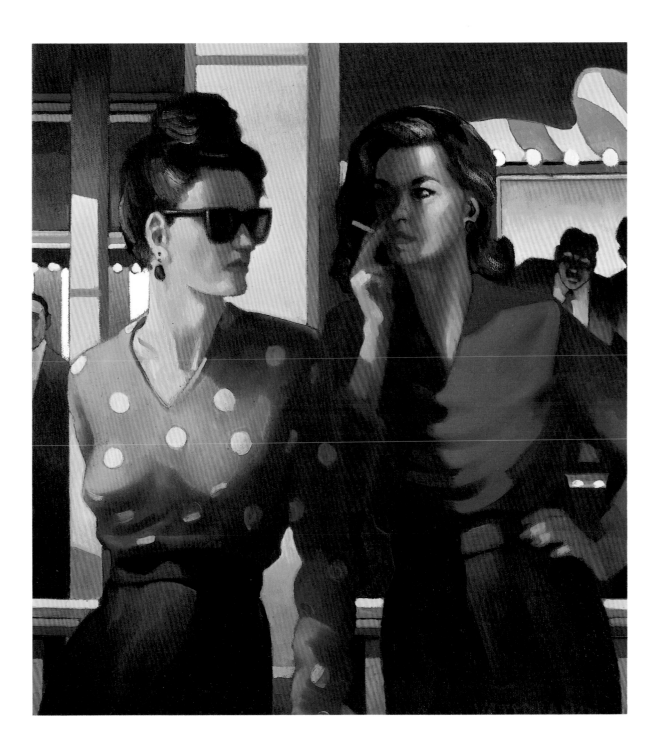

MISS MOLLY JONES, WITHIN THE COWGATE-PORT
This Lady is about twenty, rather short, good complexion, brown hair, and very good-natured. She is very well calculated for her business, and knows how to behave in a proper manner to her lovers, and gives general satisfaction in the Critical Minute.

MISS RUTHVEN, NICHOLSON'S STREET
This Lady is black and comely, middle-sized, agreeable and very good-natured. She is very engaging, and loves the sport very well; and when she is in the height of her devotion, she will turn up her eyes with the utmost rapture, upon receiving the precious unction of life. She has a number of admirers; and, in all her amours, pays particular regard to decency.

MISS INGLIS, AT MISS WALKER'S
This Lady is short, black hair, bad teeth, and about twenty-four years old. She is foolishly good-natured, and many one takes advantage of her upon that account. Notwithstanding, she is no novice at the game of love, for she is remarkably fond of performing on the silent flute, and can manage the stops remarkably well. She twists round you like an eel, and would not loose a drop of the precious juice of nature, not for a kingdom.

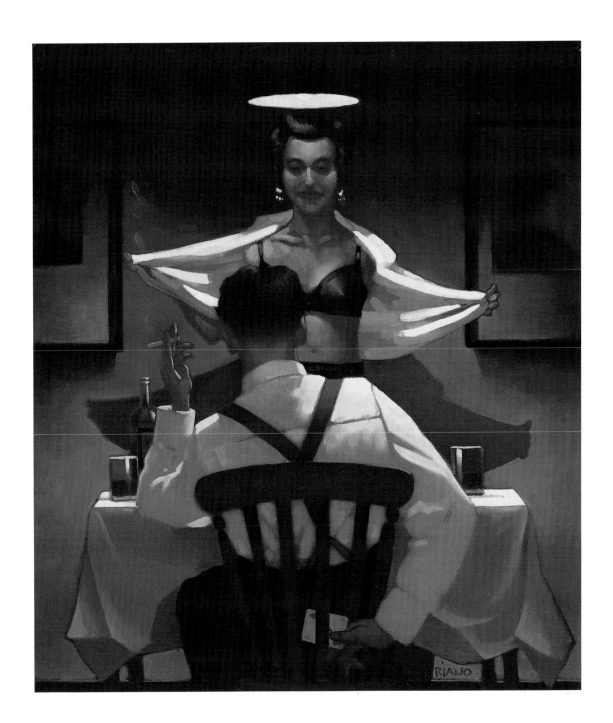

MARIA MAGDALENA

SUE GLOVER

When I'm there on the street, dressed for work,
 up for hire,
It's not me. When I'm there, I'm not there,
Just the bones, just the tits, just the bum,
And the legs, up to here, legs for hire,
I'm not there, it's not me, I'm not there.
Red rouge and mascara,
Lipstick and eyeliner,
Legs to here, lace to here, skirt to here:
In the dark, on the street, what you want,
 what you see, what YOU PAY FOR –
It's not me.

The lust that you bring me,
The thrill that you buy,
The sadness you pay for,
The dirt that you pay for,
The ghost that you long for –
The ghost that you lay –
Is not me. I'm not there
When I'm there on the street, dressed for work,
 up for hire,
It's not me...I'm not there...it's not me.

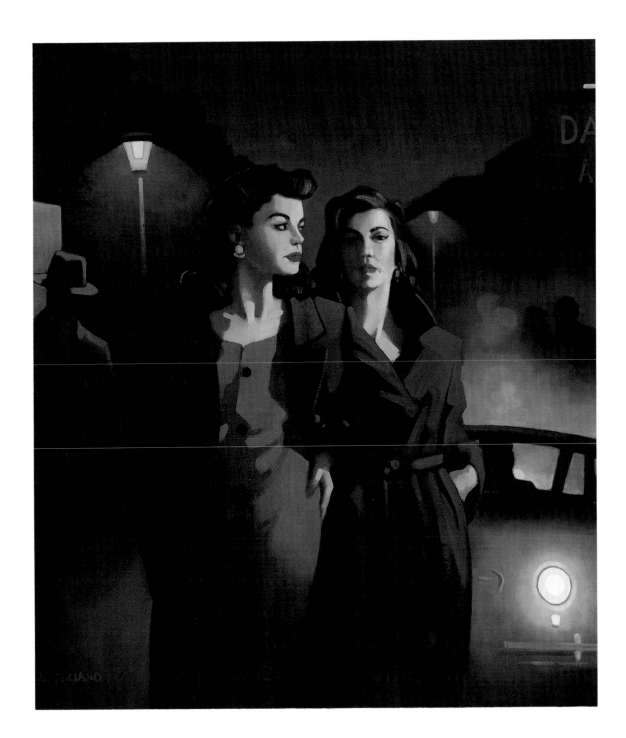

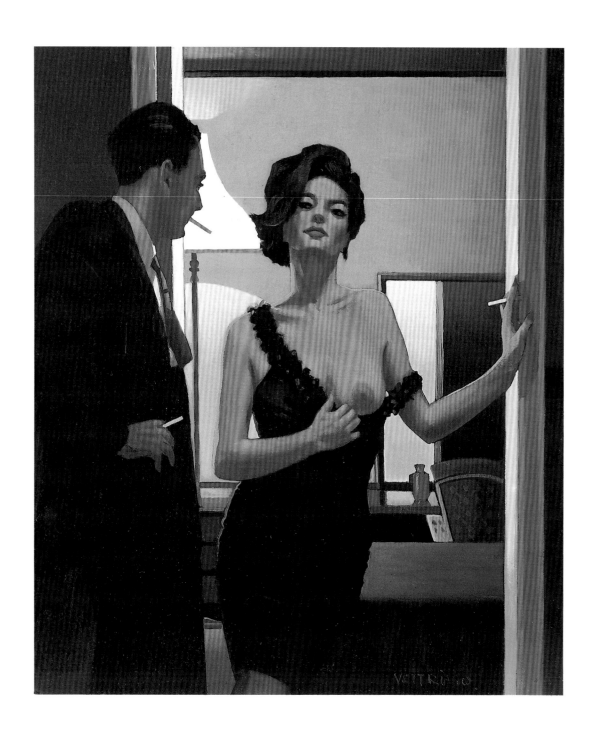

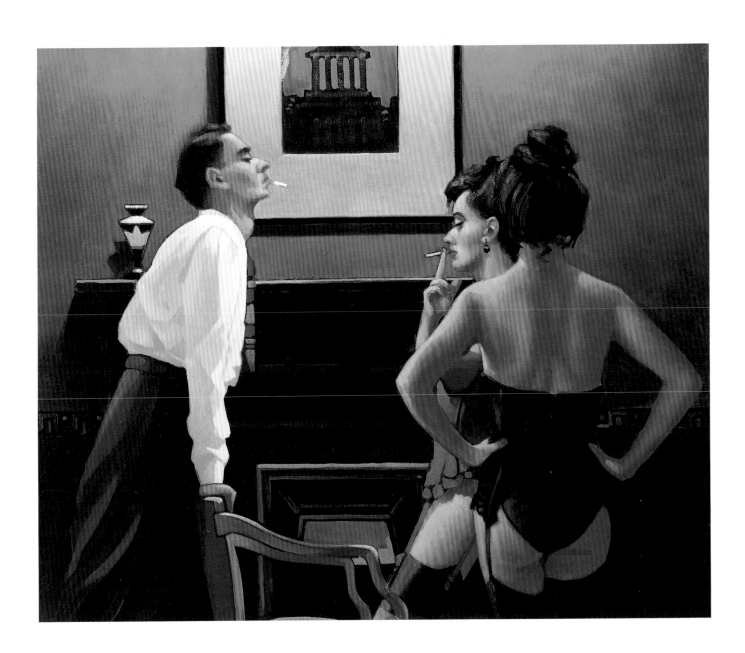

AN ASSIGNATION

JOAN LINGARD
(*from her novel* After Colette)

Two hours later, Solange emerged, perfectly coiffed and made up, dressed in yet another expensive outfit – this time in egg-yolk yellow and black. She stopped on the pavement to appraise the sky and obviously decided to walk, in spite of the height of her heels.

Amy, who by then shifted her position from opposite the Picards' apartment to the corner of the rue Valéry, set off after her on leaden feet. Solange sauntered, her hips swinging from side to side; Amy longed to run, to get the blood pumping back into her feet. Solange strolled up to the top of the avenue, then cut across Victor Hugo, Kléber and Marceau to the Champs-Elysées. She looked like a woman with nothing particular to do, a casual boulevardier. She stopped to look in shop windows, she moved on. She did not once look back; if she had, she would have seen a woman in a fawn raincoat, hair obscured by a cinnamon-brown beret, wearing dark glasses. Amy's spying kit, Camille called it. ("Don't imagine I feel proud of this episode," Amy said to me.) Halfway down the Champs-Elysées, Solange went into a café and settled herself in the glassed-in terrace, where she sat for a while drinking coffee and observing the crowds. Amy, stamping her feet behind a news-stand, began to regret her wasted day off. But when Solange rose Amy went too, drawn after her like an iron filing being dragged behind a magnet.

Solange turned right at the foot of the Champs into the avenue Montaigne. Amy began to feel now that she must have a target, some destination; she was walking more purposefully. She crossed the road and went into a brasserie on the corner of the rue Bayard. Amy saw through the glass a blurred shape – a man's – come forward to meet Solange. Their bodies merged, their heads

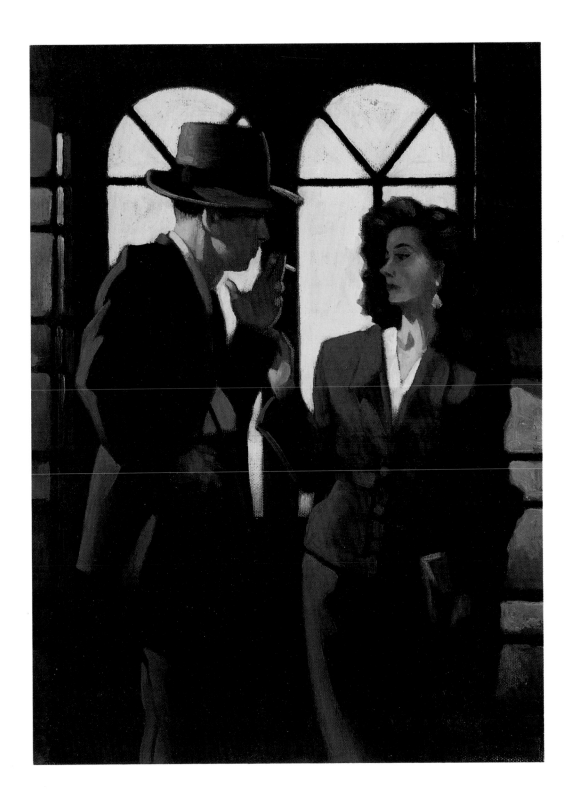

bobbing from side to side in true French fashion as they exchanged double kisses, which could mean anything or nothing.

Amy had a further two hours of hanging around to contend with while they lunched. She walked past the window twice, saw their heads close together across the small table, talking, laughing. When she walked past the third time, she saw that the man had his hand on Solange's rounded, silken knee.

At half-past two, they appeared in the doorway of the brasserie. Solange took the man's arm casually and unselfconsciously, and they turned into the rue Bayard. A few yards along they stopped to kiss, not the bobbing-about-type one as before. When they broke apart, Amy heard Solange's high curling laugh of anticipation.

They went to an apartment in the place François Premier, and there they remained for the rest of the afternoon.

IAN HAMILTON FINLAY

When I was young and we had our money – we lost it afterwards – we kept a maid. That is, we kept several, one after another, but I remember only one of them, the maid Peggy, a plump, grown-up girl with rowan-berry red cheeks, black hair, a white apron and a black dress…

Our house was two-storeyed, and Peggy must have had a bedroom in it, but the kitchen was really more her place. I mean "her place" in the nice sense: the place you would normally go to look for her, and where, in the evening when the work was finished, she was free to amuse herself just as I was in the drawing-room upstairs. The kitchen was downstairs, in the basement. This was just under ground level and was reached by a flight of old-fashioned steep stone stairs which were lit by a gas-lamp even by day.

I used to go down there a lot in the evening, after tea. At that hour, with the several straight-backed chairs tidied, the table newly scrubbed, and the day's dishes and pots and pans washed and laid by, there was a feeling in there like that of a sunset – a beautiful, still, sad sunset when the birch and pine trees, even the brackens, are so very, very still it is as if they have been bewitched…Just such a feeling was over the chairs, the dewy table, the neatly stacked dishes and the shining pots and pans that hung in a row from the same shelf.

"Peggy?" I would say as I came in. "Peggy? – Peggy draw me a face."

She might be seated in front of the big kitchen range which, being now closed and banked-up for the evening, was – in this indoor sunset – the equivalent of that faraway, bright rosy band above the woods. Or else she might be seated, hands propping her chin, at the table, bent over a love-story magazine, a weekly magazine printed on a coarse, off-white sort of paper and with illustrations in black line.

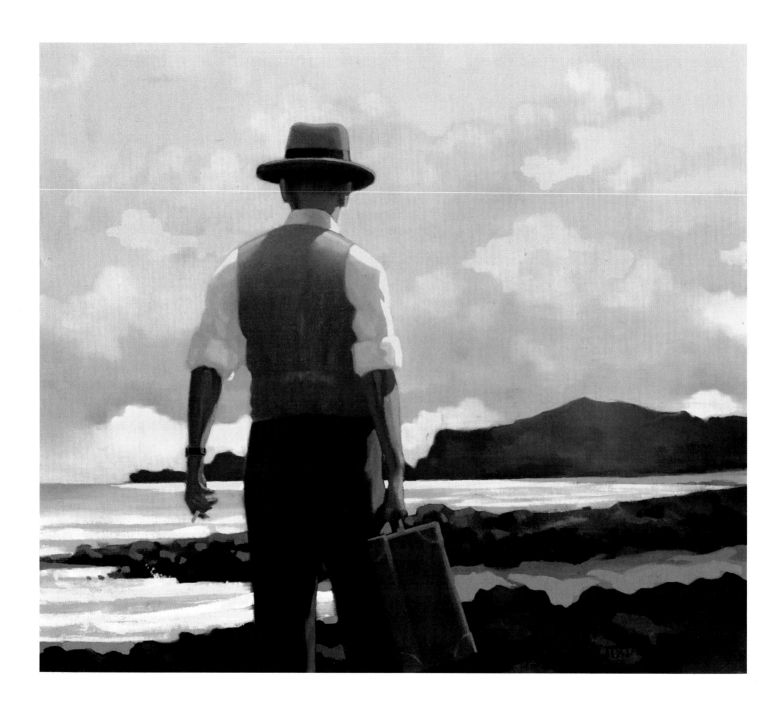

Almost certainly she would agree to draw me a face. And, in practice, that meant several faces, copied either from the illustrations to the love-stories in the magazine or from those to the advertisements (for corsets, cheap scent, and so on) that appeared on the pages towards the back. She would fetch the writing-pad, the pencil and india rubber; then, having carefully sharpened the pencil to a fine point with the old kitchen-knife, she would begin to draw me a face…

How can I say how lovely it was? I would lean up close to her, my elbows on the table, scarcely breathing – breathing very slowly through my open mouth while I held my tongue curled up just as if there was some mysterious, radar connection between the carefulness of the moving pencil-point, and *its*…Then, after a while, a sort of painless pins-and-needles would start to creep up on me, beginning, I think, in about the knees; and after another while I was half-asleep…As for the face Peggy drew, it was one with long, literally shiny eyelashes, two dots for nostrils, smiling rosebud lips, and bobbed hair. (This I pictured as being of a brown colour.) And, as soon as one face was completed, "Now draw me another, Peggy," I would say. Because I couldn't bear that she should stop drawing and so break the magical spell…

One night I met my mother at the head of the stairs down to the basement. She said. "You're not to go down to see Peggy tonight."

"Oh, but Mummy," I protested, "why can't I?"

"Never mind! Why should you, a child, be told why you can't? You just aren't to go down; that's all."

I turned and went into the drawing-room, but later, my mother having for some reason gone up to her bedroom, I did go downstairs.

Everything in the sunset kitchen was just as usual, except that an unfamiliar, grown-up young man was seated on a kitchen chair, opposite Peggy, to one side of the range. He was seated very upright and very silent; and he wore a blue suit and had a red face and hands which, spread out stiffly on his blue knees, were exactly the colour of Lifebuoy soap. What was *he* doing here? I thought. And as he, it seemed to me, was ignoring Peggy, I decided to ignore him, too.

"Peggy?" I said. "Peggy? Peggy, draw me a face."

Imagine my astonishment when she shook her head and said, "No. No faces tonight. Just you be a good little boy and run away back upstairs."

And the young man, suddenly taking his eyes, as it were, from that rosy band above the woods, said, "Go on, sonny. Listen. There's your Mummy calling you. Now run along."

That, of course, was untrue, but I went. I left the two of them alone there, silent, their straight-backed chairs like two separate rocks. I wondered if they really were as bored as they seemed.

And after that the young man came into the kitchen in the evening quite often. Harry something was his name. Once he had a thick bandage across two fingers of his right hand. Peggy said he had hurt it at his work. He always sat very upright and very silent, and then he pretended to hear my mother calling me from somewhere upstairs. One night when he wasn't there I noticed that Peggy was wearing a new ring...

"What's that?" I asked her.

I spoke softly, but even so I broke the magical spell that lay on us as we sat drawing faces out of the love-story magazine.

"That?" said Peggy. "That's a ring."

"Yes, I know," I said. "But what's it for, that ring?"

"It's an engagement ring," she said.

"An engagement ring – what's that?"

"It means I'm going to be married."

"Now?"

"Soon."

"To Harry?"

"Yes, to Harry."

"Oh. Now draw me another face. You've spoiled that face," I said.

And the young man, Harry, came more, and then still more often. So that we never drew faces. I have the impression that he was in the kitchen – Peggy's kitchen – every night. And a long time, maybe four or five whole weeks, passed. The bad time had an end one night when, as I came into the kitchen expecting to see Harry there, I found Peggy all alone and, as I thought, fast asleep. Her arms were folded across the love-story magazine, which wasn't open, and her head was laid on her arms.

"Peggy? Peggy?" I said shaking her by the shoulder. "Peggy, draw me a face."

After all, she wasn't asleep, but she didn't look up then – only shook her head once or twice.

"Oh go on." I pleaded. "Be a pal. Just one face."

"No, please." She shook her head again, several times. "Please no faces tonight."

"Oh *please*, Peggy. Please. Just one. If you do – ," I hesitated, "– if you do you'll be my best pal, for life."

So Peggy stood up, and she went through the beautiful, still, sad sunset to fetch the drawing things from the shelf. Her eyes were swollen and red round the edges as though, maybe, she had been crying; and as she stood sharpening her pencil with the old kitchen knife I could see a red mark on her finger where she had had the ring. Then she opened the love-story magazine and began to draw me a face. I leaned up close to her, scarcely breathing; the painless pins-and-needles crept slowly up me. It was lovely!…Soon I was half-asleep.

THE CRITICAL HOUR OF 3AM

JACK VETTRIANO
(overheard by WGS)

Wind girns
holds house hostage
Windows shiver
rattling bones
then silence
 – distant door bangs –
silence sighs again
 – shroud wrapping round

It's over
she's gone
space and hush left
gutted hurt

Time to decide
do or don't
dare and do
Neither tomorrow
nor some time
Now

A roar
 A shriek
 A pistol click –
 kettle's boiled

Go on
Murder doubt

Toast the moment
 Veuve Clicquot?
 Laphroaig?
Tetley tea bag
Stir two sugars
 A car backfires – *ciao!*

Salute!
To Jack Vettriano
painter
To Jack Vettriano
artist
For as long as I can
if I can
To Jack Vettriano
Caravaggio of Kirkcaldy
until they find me out

I check time
such wanton
profligate time
…at the first stroke…
the critical hour of 3 am
…precisely

And I think in time
it might make a picture

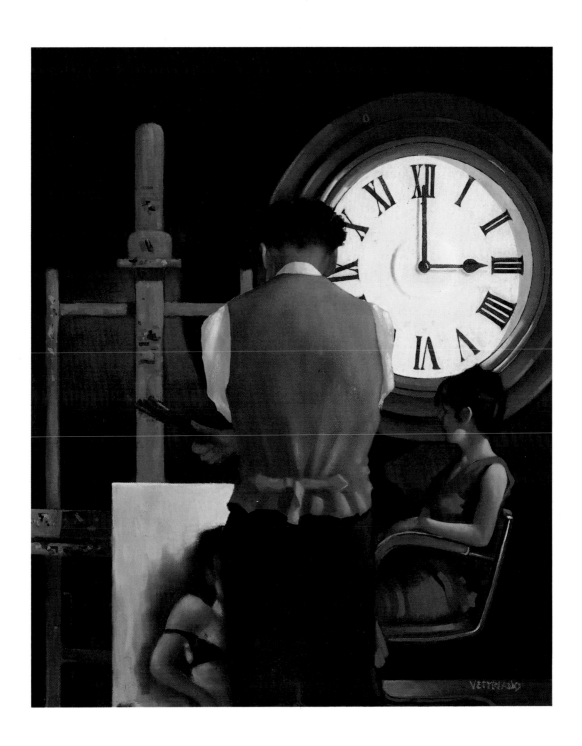

CARDWELL BAY 1937

ROBIN JENKINS

She asked him once, Did he think
She had made a good catch?
Startled, and a little wary,
For her irony unlike his own
Was shy and elusive,
He replied: Yes, he did think so,
But he had made a better one.
Serious then, she asked:
Did he really mean it?

Here they are, the pair of them,
Before marriage. In the background
Cardwell Bay, in her native Greenock,
With the hills of Argyll beyond.
He is that young fellow slouching
Against the rail, with tousled hair
And quizzical eyes.
He has rejected God.
He will be married
By declaration, to avoid
Having a clergyman present.
He supports neither side in Spain.
All wars are to him barbarous.
He distrusts politicians of any hue.
He has a contempt for judges…
He knows humanity is capable
Of every imaginable cruelty.

He says he prefers animals.
He is poor. That suit is cheap,
Those shoes are down at heel.
He is prouder than Carnegie.

What does she see that causes that smile?
Hers is an eagerness that nothing
Will ever sour or quench.
She gives all the world, God,
Judges, politicians, soldiers, poets,
The benefit of many doubts.
She is poor. Umbrella,
Coat, shoes, and gloves
Are inexpensive. She is not bitter.
She is sure that one day
She will be able to afford better.
But there is also wonder in her smile.
Does she see herself dancing
In the ballroom of the embassy
In Kabul? Walking on the beach
In Acapulco? In Jaipur
Sleeping in a rajah's palace?
Wherever she is, in peace or war,
She will enjoy life
And inspire him to enjoy it too.

Yes, my love, I really meant it.

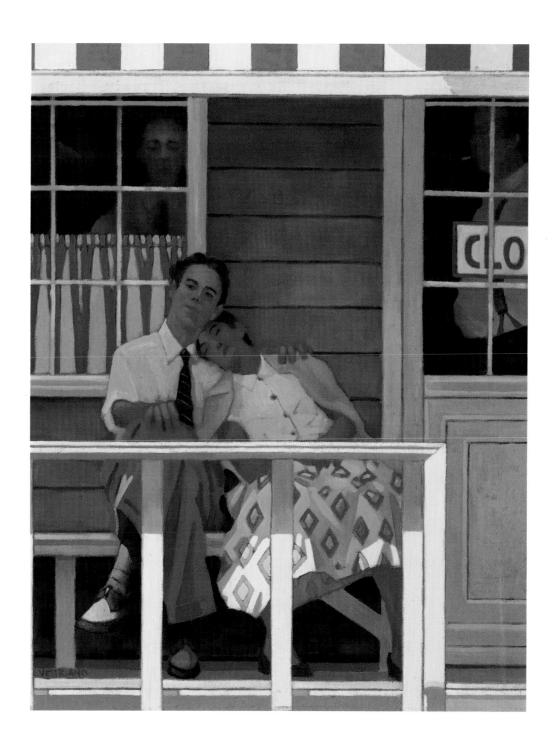

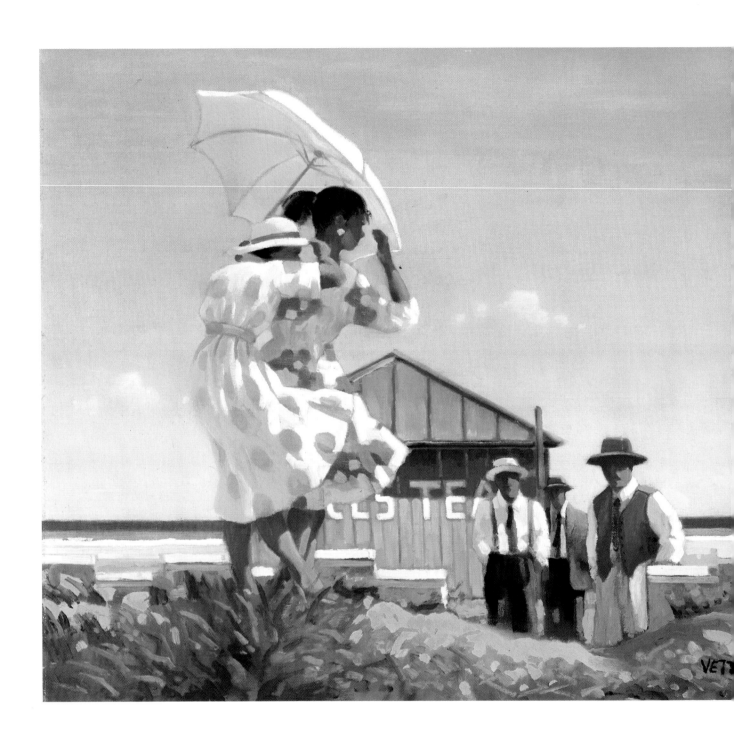

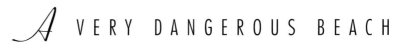 A VERY DANGEROUS BEACH

JACK GERSON

(with apologies to F Scott Fitzgerald and thanks to Jack Vettriano)

I've been on this beach before.
Across the bay is East Egg
Which is somewhere on Long Island,
Jutting out, as the man says, into the body
Of salt water which is Long Island Sound.
East Egg, that's where the money lives,
Locked up in the mansions of the great,
And the good and the bad but never ugly.

Except the architecture.

Sure there are mansions too on West Egg.
And his is every bit as exotic.
An imitation of a French mansion.
I wonder if he even knows.

You see, Vettriano's dangerous beach
Is out of time. It's also Jay Gatsby's beach,
And he is there, in white shirt, brown hat
And jacket, staring at Daisy Buchanan,
Adoring her, while her husband, Tom,
 straw-hatted,
Pretends he knows nothing. And waits.

The actors are all there. Jordan Baker,
With Daisy, Nick Carroway in the
 background.
Only Myrtle Wilson and her husband
Are elsewhere. Also waiting.

The tragedy will happen.

Jay Gatsby or Jimmy Gatz set it up
A long time ago in his life.

And seventy odd years later
Jack Vettriano was there too
To show it as it was. And is.

Gatsby would have liked that.

WOMAN PURSUED

JOY HENDRY

Fear clutches the throat.
The wolves close in.

Time, the deer, is in my throat,
the jackals clamour for blood.

I will not run.
I turn my profile to the setting sun.
You can see my shadow turn
to accuse.

I have pride enough to kill
and style enough to take your breath away.

What does the noble stag
have to fear from mongrel hounds
who kill only in packs
and have no individual will.

I lure you fatally.

You wear your hats like ballocks
gently swaying in the gloaming breeze,
one below the other,
and your pricks are guns
whose only aim
is to fell the dear white stag.

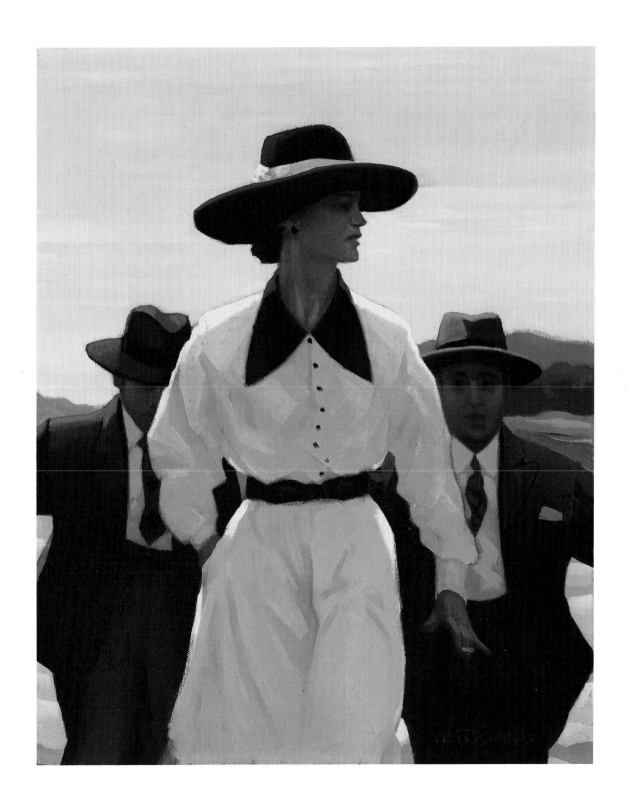

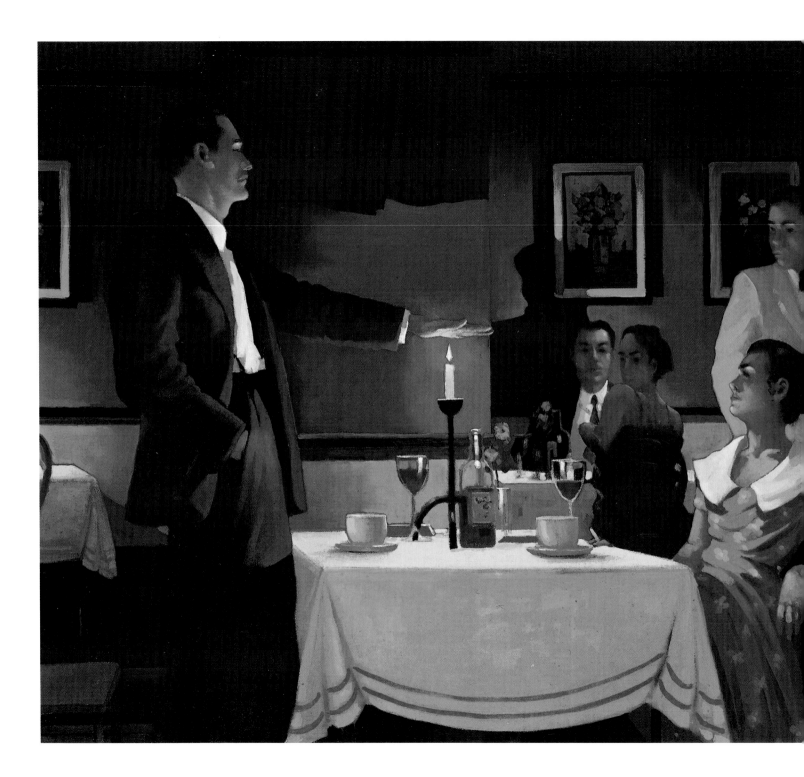

\mathcal{V}INCENT BY HIMSELF

W GORDON SMITH
(from his play about Vincent van Gogh)

My first love was Ursula, the daughter of my London landlady, when I was working for Goupil's selling photographs in the London branch.

I was twenty-one. She was nineteen.

I loved her very much, but she turned me down. Her mother forbade me ever to see her again. Apparently she was already engaged to someone else.

I have a cousin called Kay. Earlier this year she lost her huband. Before she married we got on very well together. I liked her very much. She was a gay and beautiful girl. Grief has made her dull and introspective, but she is still very lovely.

I've seen her a lot since her bereavement when she came visiting my parents. I particularly enjoyed playing with her small son. We both enjoyed it.

I fell in love with Kay. Not quickly, but deeply. Hopelessly.

This wasn't the calf-love I felt for Ursula. This was a love like pain, love such as I've never felt for any other.

It isn't easy for me to get close to people. I find friendship difficult. I give the impression that I'd rather keep my distance. People feel rebuffed. Or they recoil from my gauche attempts to form a relationship.

You can have a blazing fire in your heart yet no one comes to sit by it.

I tried very hard to conceal my love for Kay. She's a gentle, good woman. I wouldn't add to her suffering for anything. I believed she might be lonely too.

In my case, I bungled it. I blurted out my love for her and, like Ursula before her, she rejected me. She did it brutally, without sympathy, crying out, "no, no, never," as if she were pronouncing for doom. "No, no, never." Her cry rings now in my head like a funeral bell.

Never, never, never, never, never. I should have taken her at her word and left it at that. It's impossible. When you give love like that you can't just withdraw the feeling. I hoped I'd only shocked her with my clumsy and premature

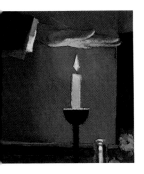

approach. I pressed that terrible "no, no, never," to my heart like a block of ice trying to thaw it. But my family won't let me near her.

I know I've behaved indiscreetly, but they treat me like a leper. I've tried to see her again. I've written registered letters expressing my love and asking her to see me.

Yesterday I went to Amsterdam where they have her closeted like a maid in the tower. I demanded to see her. My uncle invited me into the house only to avoid a scene in the street. He abused me, repeating all the terrible things that have ever been said about me – some of them true, no doubt, but all of them terrible.

I stayed very calm until he had finished. Then I asked to see Kay once more, to hear from her own lips that there was no hope. He refused, and ordered me out of the house. He would have thrown me out himself if he hadn't been afraid of my strength.

I was standing beside a small table. A tall, fresh candle burned in a silver candlestick. I looked him in the eye, pulled up my sleeve, and held my bared wrist over the flame.

"Let me see her," I said, "for as long as I can keep my hand in the flame…"

I must have fainted. I found myself out in the street, and that, so far as they're concerned, is exactly where I belong.

THE USE OF AMERICA, AND
JACK VETTRIANO

ALASDAIR GRAY

"I've a laddie in America," sang a small girl I once saw skipping under a lamppost late at night, "I've a laddie o'er the sea, I've a laddie in America, and he's goantae marry me." She had obviously grown out of her happiest time so needed hope and America.

We do not worry about death and making a living before walking and speaking. Our parents do these things for us, allowing us to feel the universe holds everything we need.

For a year or two, sometimes longer, we are allowed to enjoy life as a game played for the fun of it, so as soon as they learn to walk, healthy children hop, skip and run instead. Then "shades of the prison house close round the growing child" as Wordsworth put it. "We sentence you to hard labour for life in field, factory, office or home," says authority. "This will get you the money to enjoy some freedom in your *spare* time."

Most of us remember at least one horrid shock by which someone with authority over us demonstrated how unfree we were, but those who don't have freedom are compelled to dream of it, since freedom is a human essence and freedom used to mean America. The USA was invented by people hoping for a better life, even though they bought slaves to make life better still. From Scotland, Italy, every part of Europe, the poor and dispossessed poured into America until the gates were suddenly closed to them in the 30s. But the land of freedom and opportunity for all lived on in the Hollywood movies.

At the height of the world's worst economic depression before the present one, in Westerns and domestic comedies and crime thrillers, America broadcast itself as a country where there were only two classes, the good guys and the bad guys. They all spoke the same language. A miner, clerk, company boss, editor, cowboy, sheriff, President might be good or bad, but if they were good they were buddies at heart, and spoke the same language. They married beautiful good women and

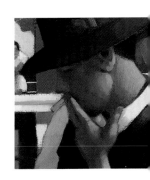

lived happily ever after without working too hard. The bad guys also spoke the same language, unless they were English villains. They said and did nastier things and possessed beautiful bad women.

Most British children and their hardworking parents found fantasies of good or bad American life came easier than fantasies of good or bad British life. They knew too much about Britain where freedom, beauty and happiness seemed the property of a class which speaks a language taught in universities and expensive private schools.

We know that the people Jack Vettriano paints are American because of their clothes and the style of the women's make-up. These belong to a time when American films promoted worldwide images of sexual excitement and adventure, through posters, cartoon books, magazines and advertisements.

The good-time girls, lonely women in dance halls, bars and hotel bedrooms could easily be Scottish. So could his men. The interiors and exteriors where we see them could easily be found in places we could all have visited in childhood or find in Britain today. The bright warm steady sunlight of his outdoor scenes strikes us as American because we don't expect it in Britain, but when we were children on holiday we expected it and got it.

There is nothing special about two young men playing cards on a bench by the seaside. Many young men play cards while on holiday. It's a cheap and comradely pastime if you don't stake big sums. Waistcoat and tie was the uniform of the respectable working man on holiday before the 1960s; only posh or bohemian types went in for open-necked shirts, even on very sunny days, but would a couple of Scottish or English friends have played a card game on a public bench in Portobello?

No, only in America could a couple of pals expose themselves so shamelessly. Apart from some sadistic rituals in private rooms Vettriano shows scenes of very possible and commonplace freedom and glamour. If he didn't translate them into American we wouldn't believe him. And now, thank goodness, this former mining engineer with a talent for colour can sell his American scenes to people who talk the language of the British universities and expensive private schools. They, too, must have had fantasies of a classless free society. I wish we would get together and make one.

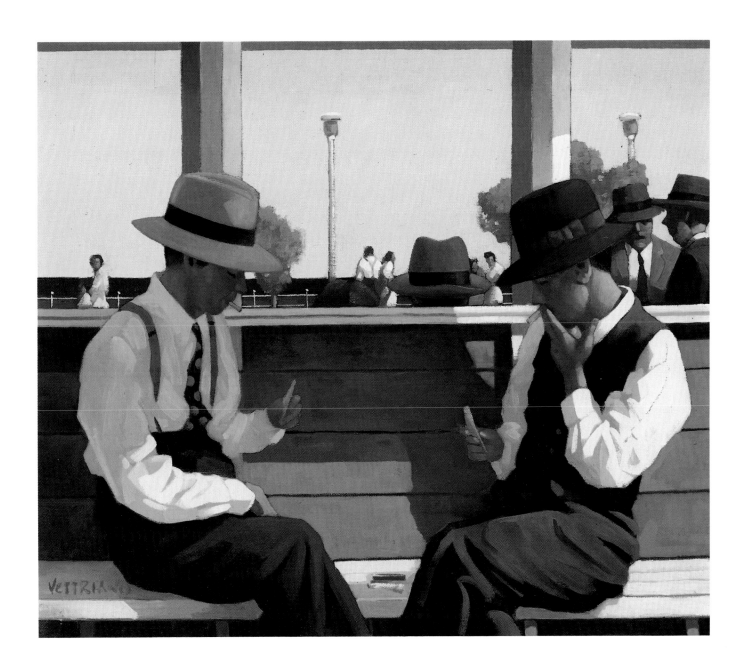

THE ADMINISTRATION OF JUSTICE

A L KENNEDY

Not long after I met her, I gave away all of my clothes. Coming home from our first proper evening with nobody there but ourselves, I knew that I just wouldn't do as I was.

That night I got undressed with the lights off and climbed into bed in the snug, slow way I was used to, so that I would be comfortable, but I could not be at ease. Although we had hardly been intimate – had barely touched – my skin and sheets, my pillows and my brain smelt of her. The whole mattress was roaring beneath me with the rhythm of her walk and I couldn't sleep. So at some point between my lying down and morning I realised that I could never wear my old clothes again. Everything around me was changing and waiting for me to do the same.

I respected my decision when I woke, but in a gradual way. Forgiving myself for a necessary piece of backsliding, I put on a familiar pullover and corduroys I had been fond of before filling two black plastic bags with dull, soft handfuls of my past – other pullovers, other corduroys, tired shirts, five pairs of blue socks and seven pairs of grey. My final inventory was unimpressive. For some reason I had imagined there might have been more, an unexpected waistcoat, a forgotten set of overalls, but the finished catalogue was only predictable and slightly sad.

On my way back from the Cancer Research shop where I left my black plastic bags, I bought a pair of jeans and a sweatshirt, a pack of assorted and colourful underpants and some short, red socks.

Home again, I removed the last of my old self, folded it into a carrier bag, redressed in my new self and went out to pay a call on Save The Children. I had found there are far more charity shops than I could ever manage to have clothes. For the next month or so Cancer Research showcased various items from my wardrobe in their window. I became used to walking past a tailor's dummy, unmistakably wearing matching selections from me. Often I didn't intend to look, but my eye would be coaxed aside as if it had been caught by an unexpected mirror and there would be my headless, dumpy ghost, relentlessly

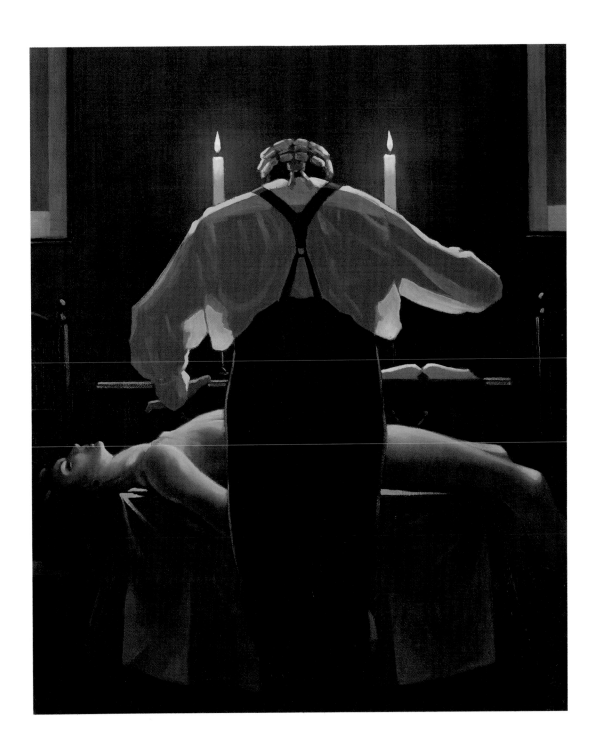

modelling how I had been. I would try to align my reflection with whichever shabby assembly stood between the record collection and the not-for-sale chest of drawers and be pleased when my present didn't quite fit over my past. Nevertheless, I came to hate the window and the fact that it changed so slowly, that no one was buying my clothes.

In this way I began to uncover and recognise my daily habits of hate, the sly distaste that could overwhelm me as I bathed in the evening, that could slip through the naked space between my towel and my pyjamas and cover my skin like salt. Years of careful loathing slowly showed themselves, looped around me like rings in a severed tree.

I also found that whatever I make, whatever I touch repeatedly, or in any way deeply, will become a measure of my contentment. A bed, a loaf of bread, a garden – or just a little sentence – almost anything, will do. If I am its maker, its owner, then somewhere underneath it will be the stain of how I am. Happy bread tastes happy and sad bread does not. My clothes in the window could not help but show the way I stood inside them. I had made them ashamed of me.

You can look at the words on this paper and, because they are the ones I am used to choosing, they will show you the shape of me. I am here to be read in the way you might read the impression of my weight in a bed after a still night, a restless night, a night not alone.

Now, of course, I give her my words and she gives me hers back. Some of them are exactly the same – less of a conversation and more a swap – but because we touch them when we speak, we can look among our sentences and see each other.

I can see the way she is bored at the café and wants to be at home with her own work, not out late with somebody else's. I can see she is, now and again, afraid about money and serious illness but not about death. I can see the way her tongue will always be hot enough to shock. I can also see her laugh. She has an enormous, disgraceful, music-hall laugh.

Waiting in the café for my soup, I knew where she was by her laugh. I had come in because the place seemed accommodating when viewed from the street and advertised cheap meals on an orderly blackboard by the door. Inside, the atmosphere was jovial, with low, sensible music and nice chairs and, even so, her laughing exploded improperly through all the air of relaxation, making it seem quite inadequate.

I eased in between the other tables and knew that I wanted soft bread and smooth soup and a cup of warm water and I wanted her to bring them to me. I wanted her near me. I specifically ignored any approaches from the other staff, staring off as if I were profoundly distracted, or hunching over the menu with my eyes half closed by concentration. The second time she passed my table, I caught her arm. She tells me she knew I would do this which is odd because I did not.

"You're ready now, are you?" That looks sharp on the page, but she didn't say it sharply.

"Yes, yes I am. I would like some soft bread and some smooth soup, or clear soup if you have any and a cup of warm water."

"Really?" "Yes."

"What's the matter?" "I have...I *had* a wisdom tooth and now I don't, not any more."

"Oh, nasty. Today?" "Yesterday."

"The day after's always the worst. The smoothest soup is leek and potato and I'll cut the crusts off your bread." I think she did, too. This would not normally be part of a waitress's duties, but I do think that she cut off my crusts. Perhaps to eat them herself, she likes crusts. For whatever reason, I had the immediate benefit of her personal care and attention. Not sympathy, attention, something I could accept.

The following day, I brought her my tooth. I had scoured away any traces of my blood the night before. It was respectable.

"God, it's like a parsnip."

I felt proud.

"It must be terribly sore."

I nodded, light-headed with painkillers and with unkilled pain and with letting her hand hold my hand, holding my tooth. The fierce, sucking ache in my mouth fluttered when she frowned at it.

I watched her move away to bring me the smoothest soup of the day and felt something like a little stone dropping the length of my spine. Except that my spine escaped untouched. This little stone fell from under my mind, through my heart and stomach and then down further again. My skeleton was not involved, this was all flesh. The blood banged suddenly in my jaw and for a

moment I closed my eyes and let my entire self be a fierce, sucking ache until I became too frightened to continue.

I kept my overcoats. Overcoats are furniture, not clothing, and both the jackets I have were my father's, not mine to give away. Luckily, these were things she liked. Their heaviness, oldness, made her want to stroke and hold them.

I intended that she should want to stroke and hold everything I might wear, but for several days I lacked the courage to ask her what she most liked. I was in danger of buying items at random and unwittingly offending her, driving her off. But despite my reservations, necessity soon forced me to purchase a shirt in which I might go to work. Even the smallest shops offered an unreasonable depth of choice. I was lost. In despair I chose the colour closest to no colour at all, white.

And she loves white. I am completely unable to tell you with nothing but words how deeply she appreciates white.

I was safe to be terribly happy then. Simply and immediately happy. The best possible shirt I could wear for her would be white and I was wearing it. Since then I have been able to look down at her warm hand gently set against the cool of my shirtsleeve and to know how infallible her judgment in these matters can be. We are perfect together when I suit her. Absolutely right. Now I save and buy the finest shirts I can for her, good seams, reliable collars, the thickest, brightest cloth with a tight, snapping shine and that wonderful, luminous roll of folds from shoulder to wrist. It is all quite magical. She takes care of me now, advises, sees I have turned out well.

At first it terrified me when she said she was a painter. I considered how she must have trained her visual sense and then immediately felt that sense rake itself down hard over me. She let her eyes into mine, held me, and explained how she could watch any one of her café customers and then sketch them back through to the skin. Her nudes were never the result of direct observation, she hadn't needed that in years. I shivered when she blinked.

And when she finally showed me her canvases – the private, finished images of her hands and imagination, stacked quietly in her flat – I wanted to press my forehead very hard into her hands and have her hold it, I wanted to sing something funny and tuneful, I wanted to lie down and roll on her floor because I was so near to so much of her. Then she introduced me to her paintings of naked strangers and I had to lean for a while against her doorframe while my whole

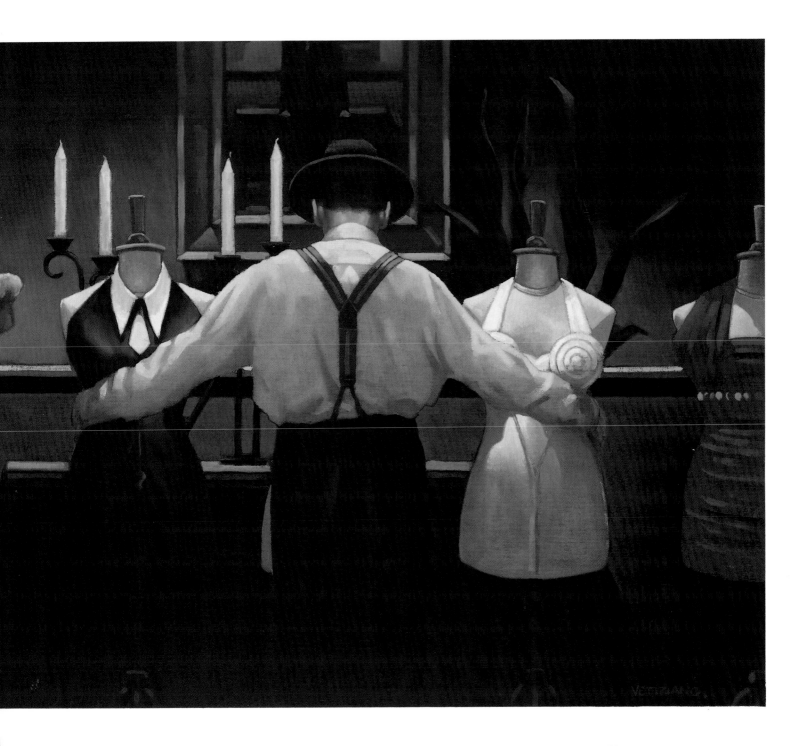

brain was shuffled and cut and shuffled right through with jealousy. I couldn't move until the feeling stopped. Within a minute she had dealt me out and back again and all I wanted was to stay back again, never to reproach or hate her because of something harmless but disturbing that she might do. Also I felt the pain of her imagination imagining me, adding the sum of my inadequacies.

To see if she would let me, I kissed her and instantly wondered how this was possible, what this meant, if this was her plan or mine. Before I left that evening, she kissed me.

I went home and cried. Or more strictly speaking, I cried on the steps outside her building and then went home and cried again.

Because I saw how terrible it all is. Nature will not let us close, you see, not close enough. Time and space both constantly tick and rush between us and we can only overcome them by concerning ourselves with each other. I must be with her, and I cannot be her maker, could not dare or wish to be her owner, so I am her lover. I love her. That is what I am for. And when I love her, I touch her. Repeatedly and deeply, I put myself in her arms. I kiss her eyes shut so that I can be with her and nothing but, none of my awkwardness or stupidities in the way. In addition, she touches me.

But I do not know the rules for lovers. I am not sure if it will be possible for me to touch her this much and not begin to change her for the worse. Because she makes me utterly contented in my mind and heart, I hope she cannot also be a sign of my contentment or its lack. I think perhaps I am a sign of hers. Except that I'm not so good sometimes, I let things down, I'm not quite the way that either of us would like.

"You worry too much."

"I try not to."

"Maybe you try too hard."

"I know. That's one of the things I worry about."

Burrowed down in the hollow of my bed, both of us in our bed, and we are talking. On the nightstand is our beautiful clutter of watches and housekeys and change, her earrings and my lucky Spanish coin which I picked out of the ice on a frozen road one New Year's Eve without being hit by even a single car. Lucky for me.

While the contents of our pockets wait for us to claim them I close my hold around the astonishing scoop and flex and blood heat of her back and feel her chuckle.

"You worry about that, do you?"

"Oh yes, I worry continually – and that's a great worry, too."

Which is the same joke we made before, but with different words and we like it anyway because we always make it and it's ours and funny and true. I wait, spooned against her, while she starts to laugh and am quite sure that I will worry for as long as I know her. She is my finest thing, you see, and I want to do her justice.

I want to be passionate for her, imaginative and free, but I don't know how. I want to love her enough for me to feel it and believe in it and still be nothing but gentle and I never do know the right way. There are evenings when I can only look at her. No. No, a little more than that.

I stand above her with my weight as evenly balanced as I can judge, a slight bias towards the toes, and I tuck back my head so the base of my skull rests snug against my neck. I make my expression soft. "Relax," I think, "feel young and happy." So I do.

She thinks I'm silly - all this preparation, complication, delay. I tell her there are times when I have to be formal. With her permission, although I need to touch her more than I need to breathe, I wait and do almost nothing instead. I anticipate her. I offer her the appetite she deserves. My eyes close and I watch the after-image of her whole skin, here in the dark with me. I shut my eyelids very gently, they don't make a sound. In that respect, I am as silent as light, or as one of the pictures she's made of me. She'll even paint ugly old me, make me part of her work because I have individuality which is far better than prettiness.

I pause.

When I begin to raise my arms, the rustle of cotton from my shirt is patient and dry and somehow quite correct.

From this position, I find it simple to lean my face forward, slowly and down. There is a thin sweat around my mouth which my movement through the air makes chill.

From here, I am almost with her. In the purely vertical sense we must be, at most, three feet apart. I lick my lips. Once. So I can taste her.

Soon I will lie with her and try to be my best. For now, I stand where she can see me while I think that for all I have left of my life she has made me unfinished when I was so sure I was done. There is no adequate repayment I can offer her for this. I worry and I do what I can.

To you let snow and roses...

ROBERT LOUIS STEVENSON

To you let snow and roses
 And golden locks belong.
These are the world's enslavers,
 Let these delight the throng.
For her of duskier lustre
 Whose favour still I wear,
The snow be in her kirtle,
 The rose be in her hair!

The hue of highland rivers
 Careering, full and cool,
From sable on to golden,
 From rapid on to pool –
The hue of heather-honey,
 The hue of honey-bees,
Shall tinge her golden shoulder,
 Shall gild her tawny knees.

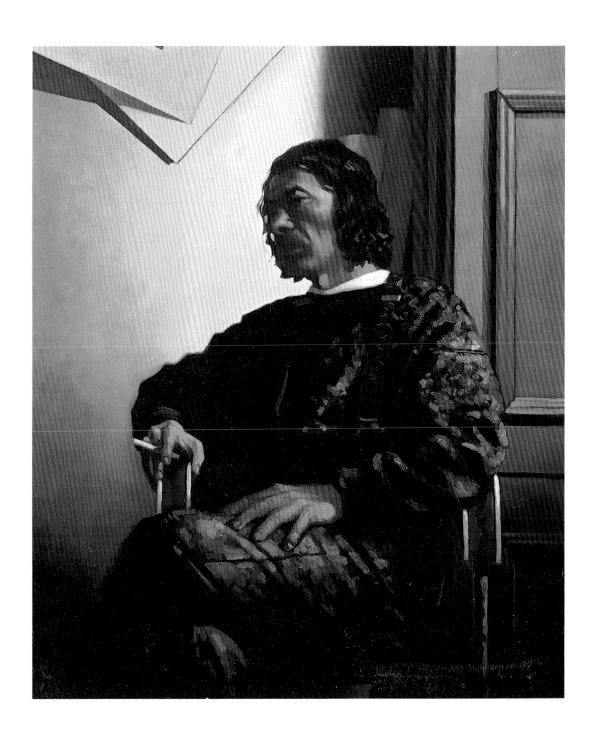

\mathcal{T}HE PAINTINGS

THE CONTRIBUTORS

ROBERT BURNS (1759-96)
 Scotland's national bard, the "heaven-taught ploughman-poet", whose love
 lyrics have been compared to Catullus.

RON BUTLIN
 Award-winning poet and novelist, also writes opera libretti; presents his work
 abroad on British Council tours.

STEWART CONN
 Poet and playwright, distinguished former head of drama for BBC
 Radio Scotland.

IAN HAMILTON FINLAY
 Internationally acclaimed artist-poet, using sculpture and graphics to
 promote his defence of classicism, and words to steal hearts and minds.

BENNY GALLAGHER
 One half of Gallagher & Lyle, superstars of the 70s, whose songs live on as
 popular standard ballads.

JACK GERSON
 Television and radio scriptwriter, novelist; creator of several successful
 drama series.

ALASDAIR GRAY
 Novelist, dramatist and painter. Prose works translated into many languages.
 Hailed as most idiosyncratic creative writing talent of his generation.

SUE GLOVER

Playwright, whose lyrical drama *Bondagers*, about the exploitation of nineteenth-century women farm-workers, has become a modern classic.

JOY HENDRY

Poet, critic, playwright, and campaigning editor of Chapman, Scotland's premier literary review.

RUSSELL HUNTER

Veteran Scottish actor, from Shakespeare at Stratford to red-nosed comedy, from Mr Callan's *Lonely* to memorable virtuoso solo stage performances.

ROBIN JENKINS

Born 1912, the doyen of Scottish novelists, notably *The Cone Gatherers* – recently adapted for the stage – and *Guests of War*. World traveller, he has taught in Afghanistan, Spain and Borneo.

A L KENNEDY

The British writing "discovery" of the 90s. Winner of many awards, including the John Llewellyn Rhys prize. Moving from short stories to novels. Born Dundee, with the world her oyster.

JOAN LINGARD

A dozen adult novels and over twenty for children. Travels and lectures all over the world but uses Edinburgh – where she was born and has lived most of her life – and Belfast, where she grew up, as background for much of her work.

WILLIAM LAUGHTON LORIMER (1885-1967)

One of the great classical scholars of his generation, he devoted the last twenty years of his life to translating the New Testament from Greek into Scots – "a majestic work of scholarship".

NORMAN MacCAIG

Doyen of Scottish poets, born 1910, recipient of Queen's Medal for Poetry. Many published collections of poems written in English but unmistakably Scottish in wit, tone and temperament.

CARL MacDOUGALL

Writer of fiction – for stage, television and radio – former magazine editor who has held several writing fellowships.

BERNARD MacLAVERTY

Born Belfast, but Scottish-based since 1975. Graduated from teaching to full-time writing of novels, short stories and fiction for the large and small screen.

ALAN SHARP

Hollywood scriptwriter – *Ulzana's Raid*, *The Hired Hand*, *Night Moves* – whose early novels based in his native Greenock established his writing career. Writing new prose work *A Blind Man on a Galloping Horse* which is "a layer closer to straight autobiography than most fiction is". His script about Scottish folk hero Rob Roy is being filmed in Scotland.

IAIN CRICHTON SMITH

Poet, novelist, short story writer in Gaelic and English. Born 1928. His *Consider the Lilies* is a modern Scottish classic. Schoolteacher for 25 years before becoming professional writer in 1977.

W GORDON SMITH

Playwright and critic. Stage biographer of Vincent van Gogh, John Knox, Mary Queen of Scots and Andrew Carnegie. His play *Jock* has been described as "a permanent piece of Scottish drama".

ROBERT LOUIS STEVENSON (1850-94)

One of Scotland's best-loved novelists and poets. *Treasure Island* has never been out of print since 1883. *The Strange Case of Dr Jekyll and Mr Hyde* is seen by many as a metaphor for the two faces of Edinburgh, Stevenson's native city.

ALAN TAYLOR

Former librarian, now literary editor of *Scotland on Sunday* and feature writer. Member of the 1994 Booker Prize judging panel.

ACKNOWLEDGEMENTS

Many hands have made light work of this happy task. I am grateful to all the writers. They looked at the pictures and responded with alacrity, invention and generosity of spirit.

I am indebted to Norman MacCaig and Hogarth Press for *Power Dive*; Joan Lingard and Sinclair-Stevenson for two extracts from *After Colette*; R L C Lorimer and Canongate Press for the extract from W L Lorimer's *The New Testament in Scots*; Paul Harris for quotations from *Ranger's Impartial List of the Ladies of Pleasure in Edinburgh*; and Ian Hamilton Finlay for permission to publish *A Broken Engagement*.

All of the paintings were photographed with sensitivity and precision by Ronnie Inglis. I have enjoyed working alongside a designer of such flair and good taste as Bernard Higton.

The project has fortified my affection for Jack Vettriano and his work. Everyone involved owes incalculable gratitude to my partner Jay Gordonsmith.

WGS